STENCIL GRAFFITI CAPITAL

MELBOURNE

Jake Smallman & Carl Nyman

Mark Batty Publisher

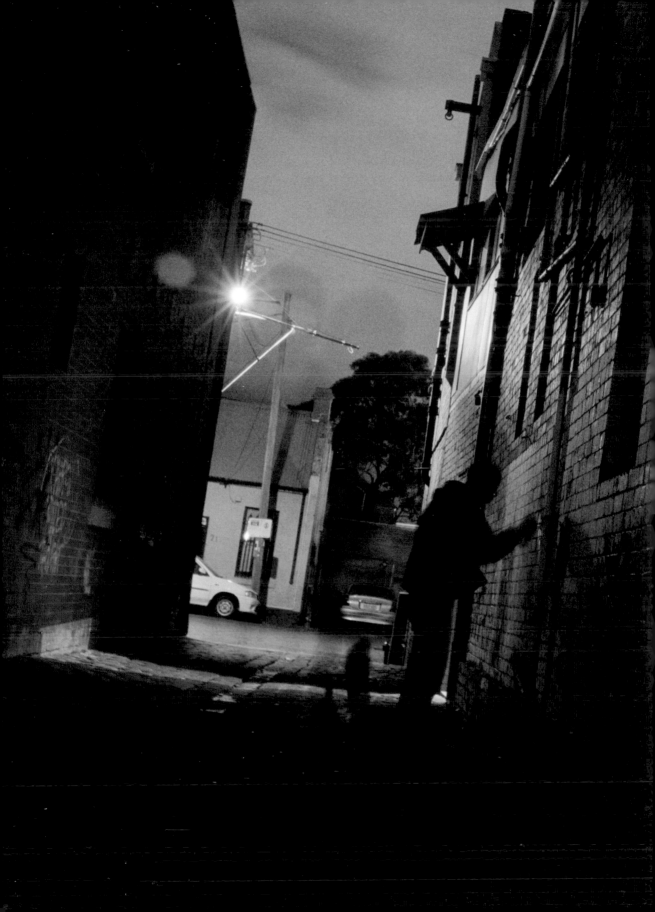

STENCIL GRAFFITI CAPITAL:MELBOURNE

Stencils just don't happen. Once the idea arrives, the design takes time; cutting the stencil may take several days. The initial steps make it possible to put-up intricate images in a busy area in under a minute. It's all about anticipation. You wait until it gets late enough to finally brave the cold and avoid the crowds. You walk around, looking for good flat spots to spray. When the stencil is pulled from its folder and gets quickly taped to the wall the adrenaline starts to pump and fear mixes with excitement. The rhythm of aerosol hisses matches the quick strokes of the hand as the paint finds its way to the surface. The second the can is put away, the stencil is peeled back. Adrenaline is replaced by another feeling: Accomplishment.

It's hard to say exactly when stencil graffiti made its debut in Melbourne. Stenciled ads for the 1986 film *Dogs in Space* can still be found. Graffiti writers sometimes dabbled in the technique, but it was usually frowned upon and considered cheating. Occasionally during the 1990s, ads appeared sprayed on sidewalks promoting everything from parties to products.

Since then, Melbourne's alleyways have undergone vast revitalization programs. Empty office buildings became apartments; bars and cafes lined the streets that bustled with foot traffic. Street art sprayed and plastered across this fresh urban landscape reflected these changes. A new breed of graffiti artist roamed the city, indifferent to the egocentric nature and territorial disputes of traditional graffiti.

In 1999, stencils bearing the moniker "Psalm" began to appear. Although small and humble, Psalm's stencils were intricately detailed, vibrantly colored and visually arresting. Ha-Ha has often claimed Psalm as an influence but in contrast to his mentor, Ha-Ha's stencils are anything but humble. He approaches the medium more like a tagger and his often blocky, roughly cut, one layer stencils usually appeared painted in black, one next to the other. By late 2001 it was hard to go anywhere in the greater Melbourne area without seeing at least one, if not many, of Ha-Ha's stencils.

Syn and Dlux had been chasing each other's stencils for quite some time in their hometown of Adelaide but never met until they both moved to Melbourne in late 2002, bringing their stencils and stickers with them. They moved into the now defunct "Blender Studios," named for the eclectic mix of artists, students and musicians always hanging around creating a blend of high and low art on the studio walls. With Ha-Ha already in residence, the crew embarked

on nightly painting missions. These artists can be credited as being the first wave of what was about to become a cultural phenomenon.

Two years later, stencil graffiti was everywhere you looked in Melbourne. The number of stencil artists working the streets increased twenty-fold. As the number of artists rose, so too did the quality and complexity of the work they produced. Driven by political agendas, artistic endeavors and a healthy sense of competition, artists developed their stencils beyond small monochromatic images. Complex multi-colored designs started to appear; stencils became increasingly larger and more detailed.

Artists like Meek, Sixten, Meggs, Civilian, Optic, Rone, Monkey and his brother Button Monkey, Satta, Vexta, Tusk, Dolk and the Co-op Collective put their own spin on the stencil graffiti phenomenon. Ecce, Reks and Numskull, from Sydney, and Victim, from far off Perth, all visited Melbourne to take part in this fast-moving scene. A visit to Melbourne by Banksy, the world's most famous stencil graffiti artist, only fueled this fire.

As action on the streets skyrocketed the loose confederation of artists that had been lurking in the city's night shadows formed into a community. Melbourne artist Prism played a major part in the growth of the community when he created the website Stencil Revolution. He also took part in establishing the first permanent, yet illegal, public gallery in the city. It was set up by painting the walls of a secluded alleyway white, then adding stencils and, via the website, letting other artists in on the action. Today, Stencil Revolution boasts over 15,000 registered users worldwide. Although the site's content is international, it soon became evident that the quantity and quality of stencil graffiti coming from the streets of Melbourne was second to none.

Suddenly, stencil graffiti was everywhere. The public noticed. The media noticed. Melbourne stencil art was being talked about on the radio, splashed across the city's leading papers and discussed in art and design journals. The initially subversive, underground stencil graffiti technique spread from the streets and into the galleries as a number of exhibitions followed on each other's heels across the city. The first was "Cut It Out" held at Hush Hush Gallery in Hosier Lane. The sold out show featured Ha-Ha, Dlux and Syn and paved the way for subsequent gallery shows.

Fortunately, the assimilation of stencil art into the cultural space of the gallery never compromised the power and frequency of stencils on the streets.

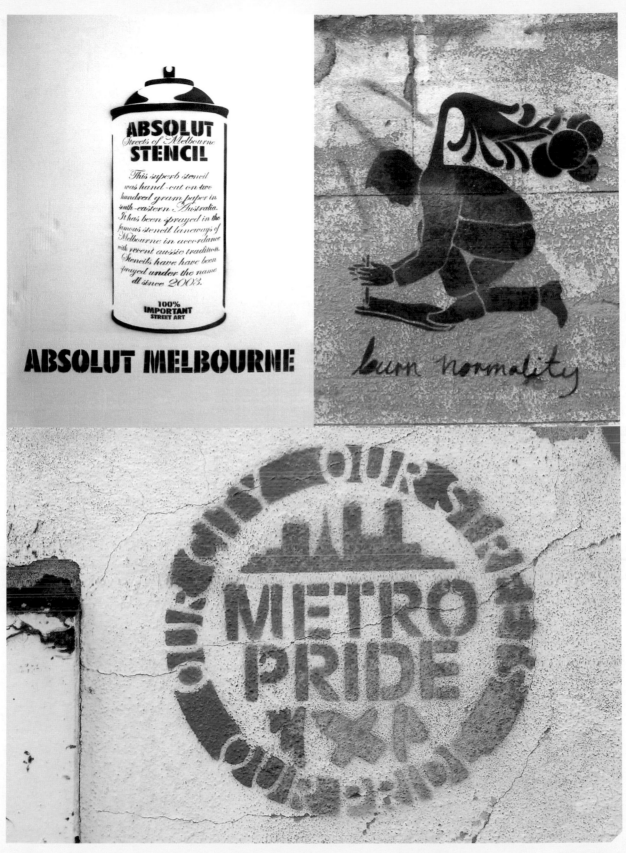

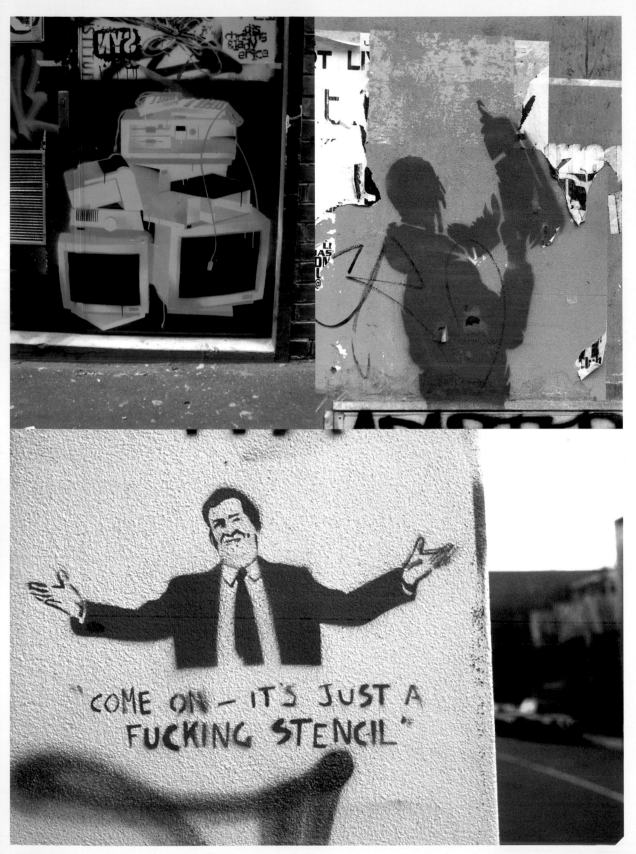

Beyond the white walls of the city's galleries, the scene continued to flourish as more and more people cut and sprayed stencils on the streets.

"Empty Shows" were a series of illegal exhibitions held in abandoned buildings around Melbourne. When a venue was found, a date for the show was set and word spread through a network of vandals and artists. For several days leading to the opening, they silently accessed the site creating works directly on the walls inside. Details of the opening were then spread by discreet flyers and word of mouth so as not to alert the authorities. Opening night, the crowds numbered well into the hundreds and although the police sometimes turned up early there wasn't much they could do other than ask people to leave.

"See Saw" was another series of informal exhibitions in Melbourne. It was a loosely organized stencil graffiti event, held monthly in the rotunda in Edinburgh Gardens. People brought their art on boards or canvas to display and at the end of the night anyone could take home a piece of art.

"Empty Shows" and "See Saw" provided artists with an opportunity to exhibit without compromising their ethics. Since neither involved selling the art, the events remained true to the public essence of street art and highlighted the close-knit nature of the Melbourne street art community. The pinnacle of stencil graffiti in an off the street format was reached with the inception of the Melbourne Stencil Festival in early 2004. Being able to run a successful four-day art event centered purely on stencil graffiti underlined the strength of the subculture.

However contradictory the message may seem at times, Melbourne actively supports the stencil graffiti community. Though sprayed tags technically fall into the criminal category of vandalism and the city's zero tolerance policy about graffiti remains on the books, the city was one of the major sponsors of the 2005 Stencil Graffiti Festival. The city is well aware that today many visit the central parts of Melbourne just to see stencil art. School groups visit alleyways and galleries; tourists come to Melbourne not just for food, fashion and sporting events, but also for its reputation as the world's street art epicenter. There are even tourist maps indicating the city's most decorated areas.

Although stencil graffiti in Melbourne still flourishes in the dirty alleyways it originated in, today, the movement's reach extends far beyond city limits. Cultural institutions such as the National Gallery of Australia have exhibited videos of stencil art from the city and have also collected an impressive amount of works on paper and cardboard. The National Gallery of Victoria and the Australian Centre for the Moving Image have both exhibited photographs of stencils in Melbourne.

In the Australian newspaper *The Age*, Anne McDonald, curator for Australian Prints and Drawings at the National Gallery, said: "The National Gallery has the premier collection of Australian prints and it's very important for us to keep up with what is happening in the current scene – it seems to be a very vibrant movement."

Although stencil artists have put their mark on Melbourne for a number of years now, this book is very much a document of an ever-evolving movement.

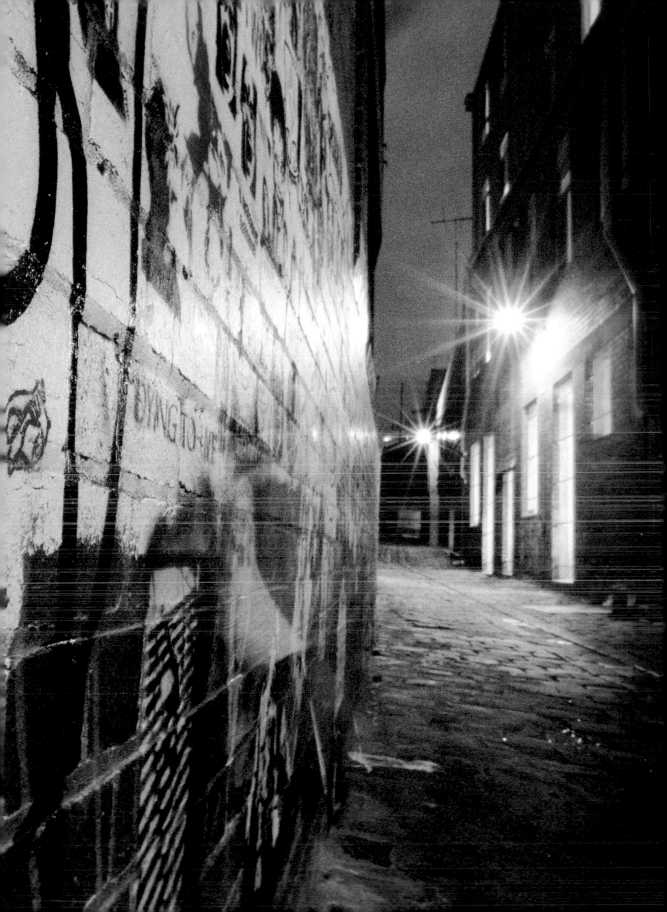

civilian

Talking to Civilian you are immediately struck by the gentleness of his voice. His tone is that of a bedtime story reader, but rather than inducing sleep it is only a matter of time before you willingly drift off and let him steer the conversation in any direction he wants. Stencil graffiti is often the destination of these conversational journeys.

"I started playing with stencils around the end of 2001," he remembers. "I was simply drawn to the conversations that were taking place on the streets. I was seeing a lot of really interesting urban interventions through the activist scene such as the whole "Reclaim the Streets" phenomenon, "Critical Mass," billboard jamming, political sloganeering, banner drops, street performance, postering and bogus political campaigns."

"I really got into the visual language through zines and hand-made books. You photocopy your artwork and trade it with your mates, then gradually distribute them more widely through friendly shops and festivals and stuff. I love the DIY nature of zines and street art, the inclusiveness of it, and that anybody can do it, the fact that no one can tell you what to do, and what's the correct way of doing it."

Civilian has had work in several gallery shows but says that he's not entirely comfortable in that setting: "I feel very confused about the whole gallery thing. It's a lot of fun working off the street, being able to take your time and really experiment but I'm just so dubious of the commercial side of it. That whole experience of reading a skate mag and every single ad in it using stencil fonts with spray-paint dribbles, or when street art exhibitions are sponsored by large corporations. It really gives me the shits, and it feels like a kick in the gut. I feel it trivializes the work of artists on the street, and tries to steal the credibility of hard-working artists. Some major corporations like record labels, clothing companies and media companies are involved in so many despicable things like using sweatshop labor, supporting repressive regimes, environmental destruction, mental pollution and general all-round bad stuff."

"I'm really into using interesting spaces for shows and hope to experiment with this more in the future, to keep pushing the possibilities of a show." One such example of interesting spaces and shows Civilian mentions are the "Empty Shows," a series of illegal exhibitions held in derelict buildings. "It's an exciting idea that's been happening this year, and probably forever under a whole other bunch of names. It's the simple idea of reclaiming space. Taking a dead, empty space, and revitalizing it. Bringing artists together to work on the empty canvas of a building, a street corner, an alleyway, a location, then having a one-off opening, get-together, and see what happens. It's basically a squatted art exhibition."

In 2003, Civilian was one of the artists busted when the police raided the Canterbury "Empty Show:" "They fully grilled me and were like, you better fucking tell the truth mate or you're getting it! Whatever that meant. They pretty much implied they were going to bash me up or something. They just walked around the whole place ripping up everyone's work and dumped all these stencils in front of me."

"I think in the past I've been a bit too blasé about being caught. I've been very confident that I'm doing the right thing, that street art is an important and necessary part of society. There seems to be no public space to interact with left for the general public. But really, it's a waste of time and money getting caught, and it's a real stress being harassed by cops."

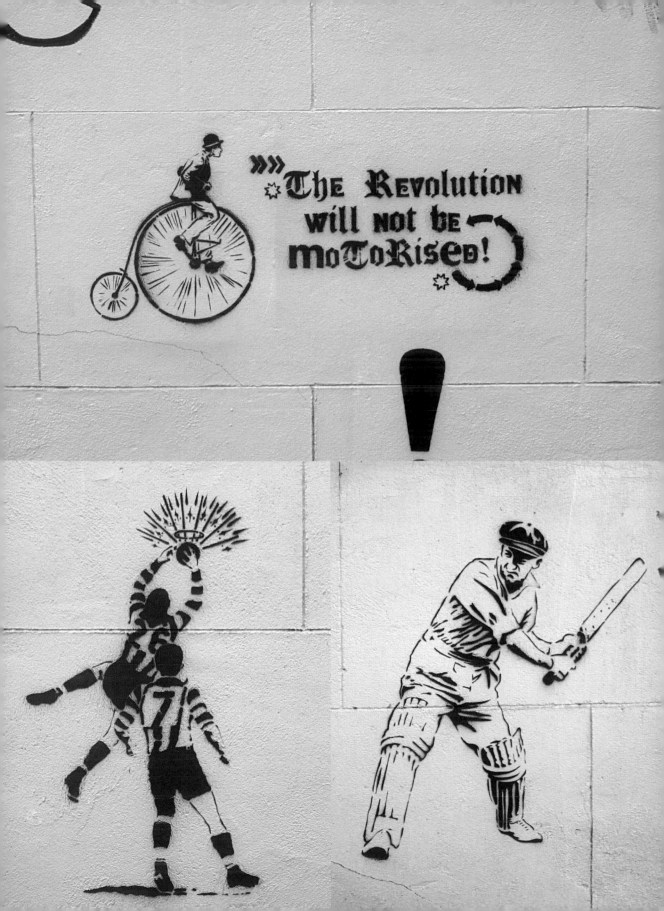

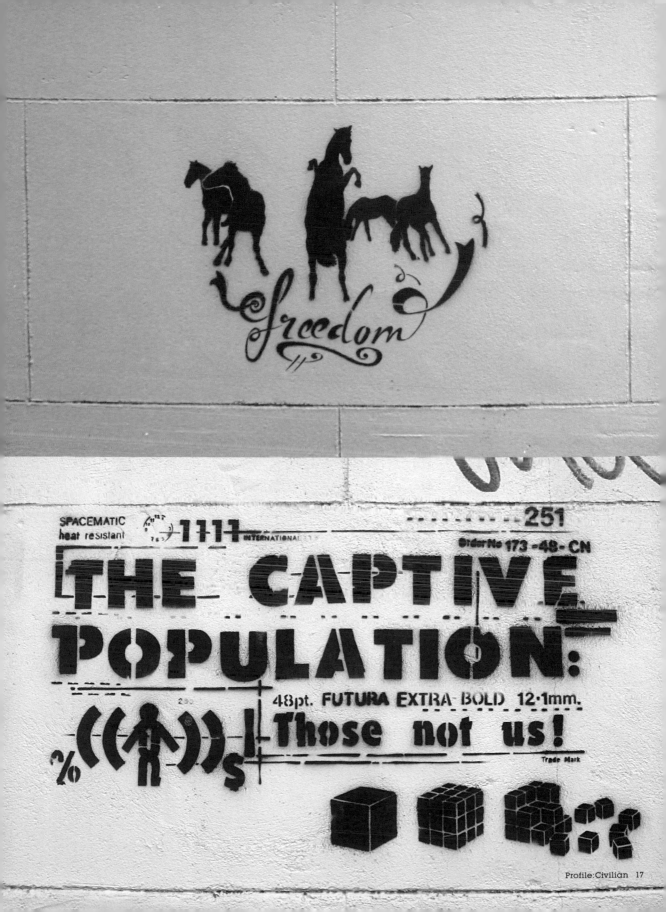

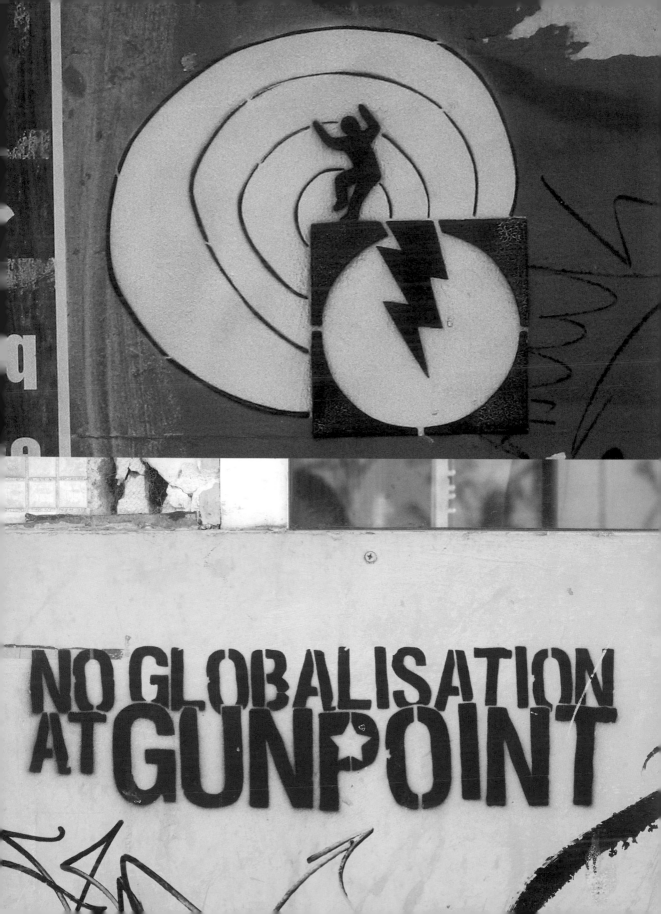

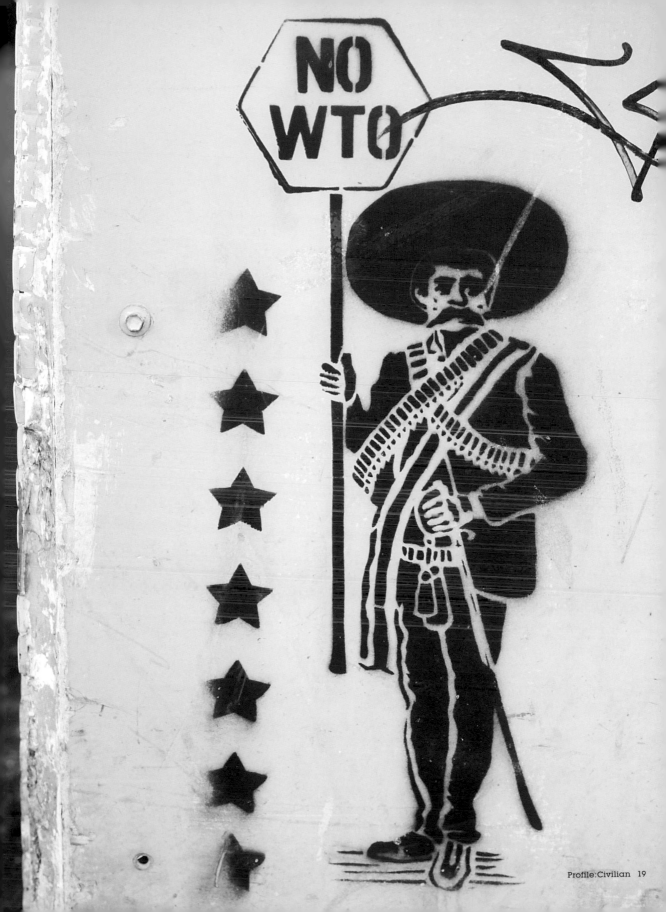

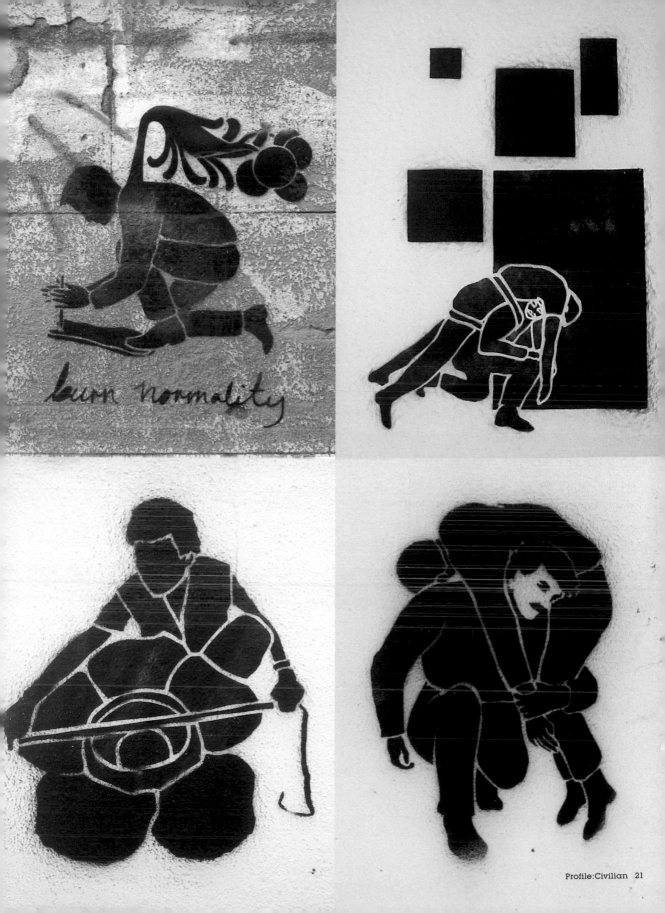

burn normality

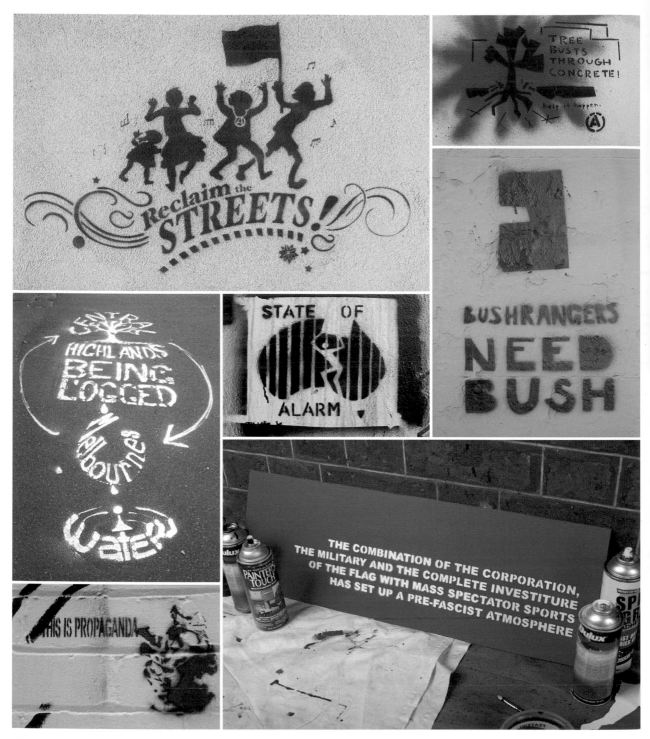

THEME:POLITICS

The political murals of Mexico City and the writing on the Berlin Wall are both regarded as crucial cultural records of political struggle. In Melbourne, politically conscious stencils tend to lean left of center – anarchist, socialist, anti-globalization and pro-refugee.

Voices for and from the margins of society declare their presence, especially for those who do not want to listen. Plastered across walls and sidewalks they force their way into the minds of the public.

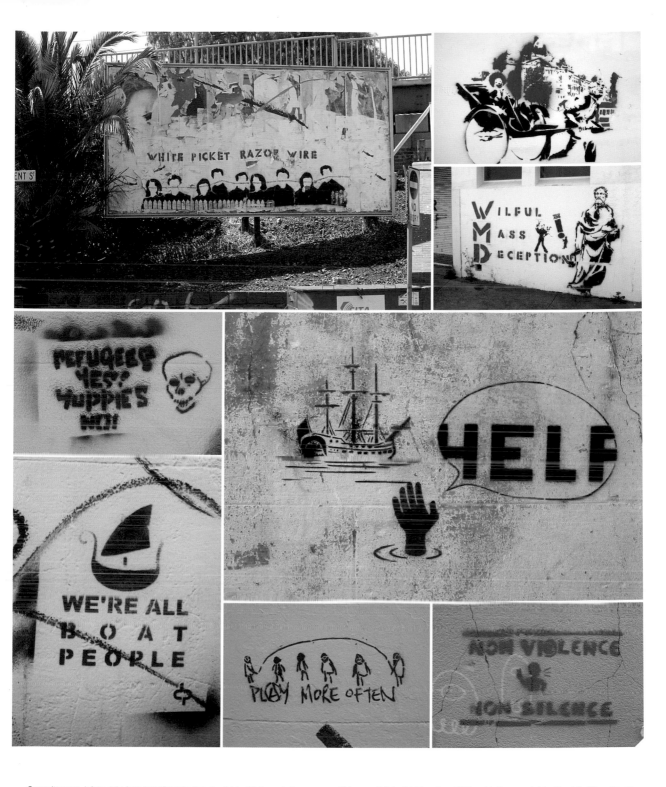

Opposite page, left to right from top: 'Reclaim the streets' by Civilian, photo: Peter Casamento / 'Tree busts through concrete' by Civilian, photo: Mark Mansour / 'Highlands logged', photo: Mark Mansour / 'State of alarm', photo: Mark Mansour / 'Bushrangers', photo: Satta / 'Propaganda', photo: Satta / 'Pre-fascist atmosphere' by Civilian, photo: Civilian.

This page, left to right from top: 'White picket razor wire' by Dominic Allen, Hazer and Mu, photo: Jake Smallman / 'Ronald and Howard' by Dominic Allen, photo: Peter Casamento / 'Wilful Mass Deception' by Dominic Allen, photo: Jake Smallman / 'Refugees yes!', photo: Satta / 'Help' by Civilian, photo: Satta / 'We're all boat people' by DP, photo: Shyam Ganju / 'Play more often', photo: Mark Mansour / 'Non-violence, non-silence', photo: Satta.

DON'T BE
SCARED
IT'S ONLY
STREET ART

Near the end of 1998, Dlux first took his art to the streets in Adelaide, a city already widely known at the time for its sticker scene. He designed his first stencils to produce large numbers of stickers. "Stenciling was just a way to reproduce a lot of images," Dlux remembers. "It's only the last couple of years that I've started working directly onto street surfaces." Dlux moved to Melbourne because he recognized it as the most exciting street art scene in Australia: "The Melbourne street art scene has an unequalled energy. There are artists, organizers and documenters constantly doing stuff and always newer players trying things out. The scene is progressive in the way it approaches making public art."

Perhaps the pinnacle of this progressive approach, in 2003 the Melbourne stencil scene successfully spread from the streets into the galleries, without losing its edge or credibility. As an artist who regularly exhibits and more recently acted as a manager and curator of a gallery space, Dlux is one of the main driving forces behind this smooth transition: "I've always been an avid fan of artwork that exists, for the most part, outside of the gallery system, it's an unsolicited space. At the same time I think that these shows are important. They give artists and audiences the chance to extend what stencil art can do. Selling art gives people some money to produce even more art. The culture will only expand through embracing the gallery context. It is a legitimization in a way, proof that people actually want to own the images and take them home."

"The gallery work I make is for more of an informed art crowd but I would like to think that it is still accessible to all of my mates. I guess it's obvious to make images for like-minded people but lately I've begun thinking a lot more about universal images that can reach the largest audience possible and have some sort of meaning for all of those people."

"There is a large part of my gallery practice that I consider separate from what I do on the street. I make street stuff that is basically fun. I'll do quicker stuff on busy streets but I'm a big fan of spending more time on larger things when the opportunity presents itself. In galleries I continue to use stencils because of their street level context. The gallery paintings I have been producing over the last couple of years have been very politically motivated. This is mostly because I find myself, and my peers, to be frustrated with global politics." A recent series of large multi-colored, stenciled posters that depict world leaders directly speaks of this political angst. With this project, Dlux found the freedom to spend the time he enjoys while producing gallery work, but also the possibility to get them out to the public by pasting them up in the streets, a fairly quick process that lessens the risk of being caught but does not diminish the overall accessibility of the work.

About the legality of stencil art he says: "It's all criminal damage. I'm less likely to bomb someone's house than a public building unless it's a particularly good spot and lends itself to creating an overall beautiful image." Being one of the most active painters on the Melbourne street scene, he admits to getting a lot more nervous these days: "We know they've got detectives trying to bust us. Nobody local has been busted yet so we don't quite know how they're going to screw us. It's likely someone will be made an example of. The charges will probably only be fines but I don't want to have to tell my mum that I'm going to jail."

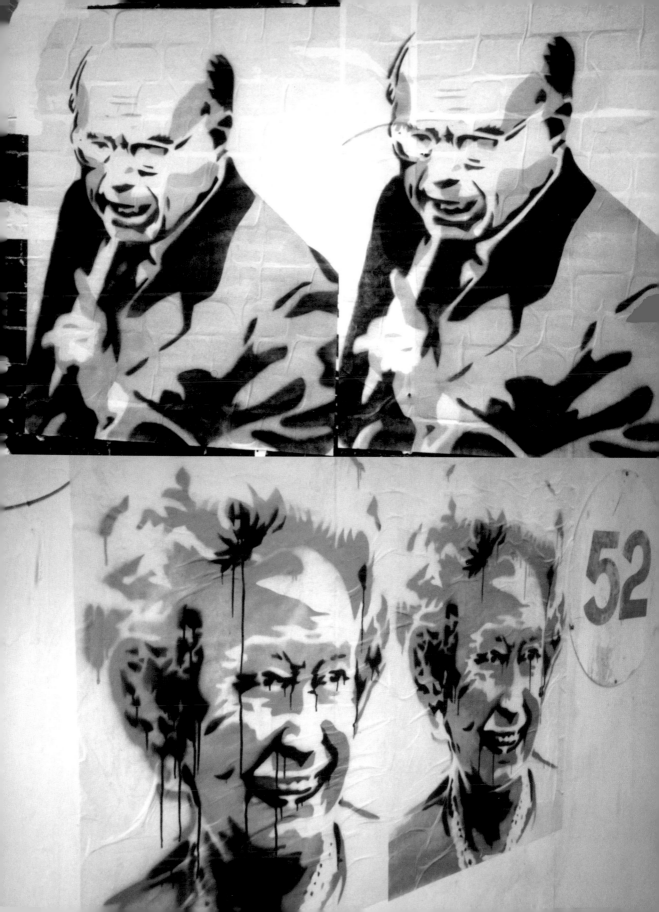

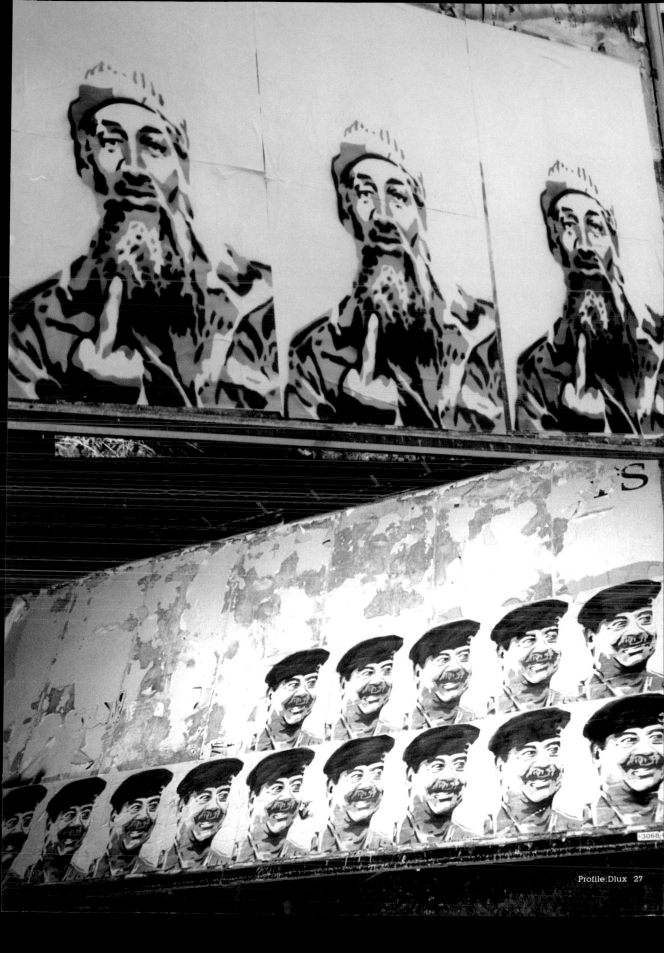

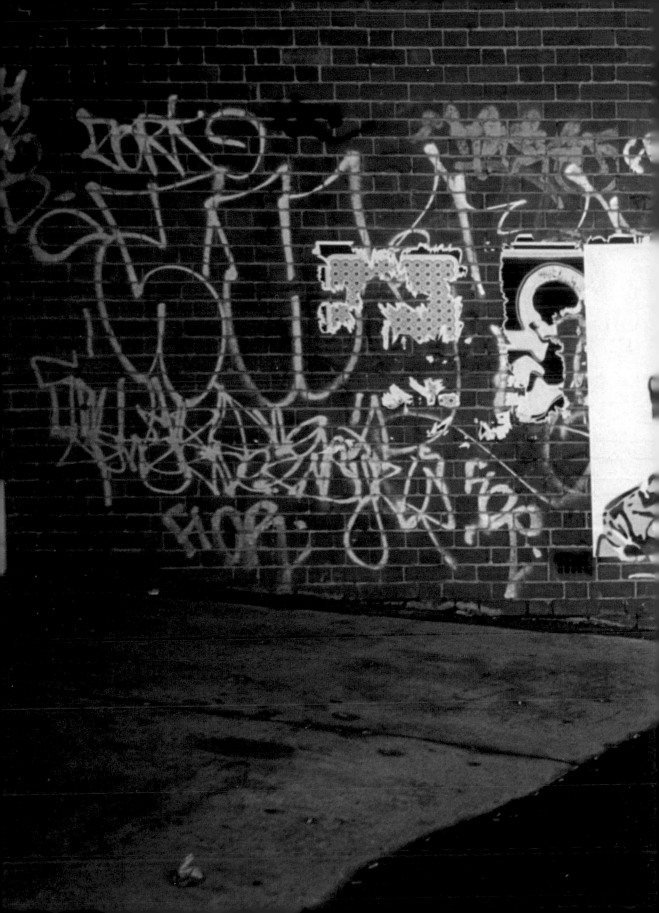

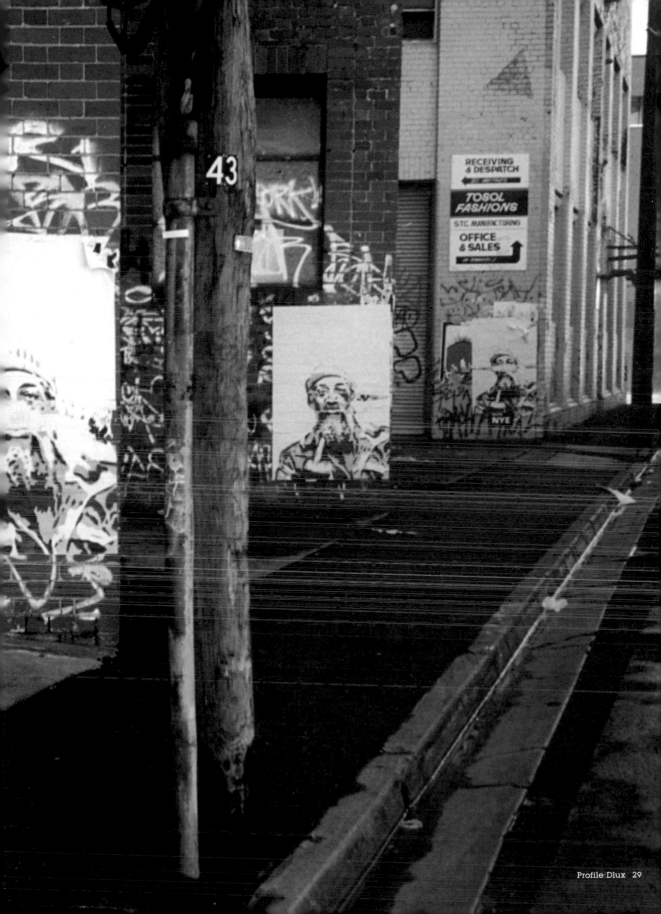

43

RECEIVING
& DESPATCH

TOSOL
FASHIONS

S.T.C. MANUFACTURING

OFFICE
& SALES

NYE

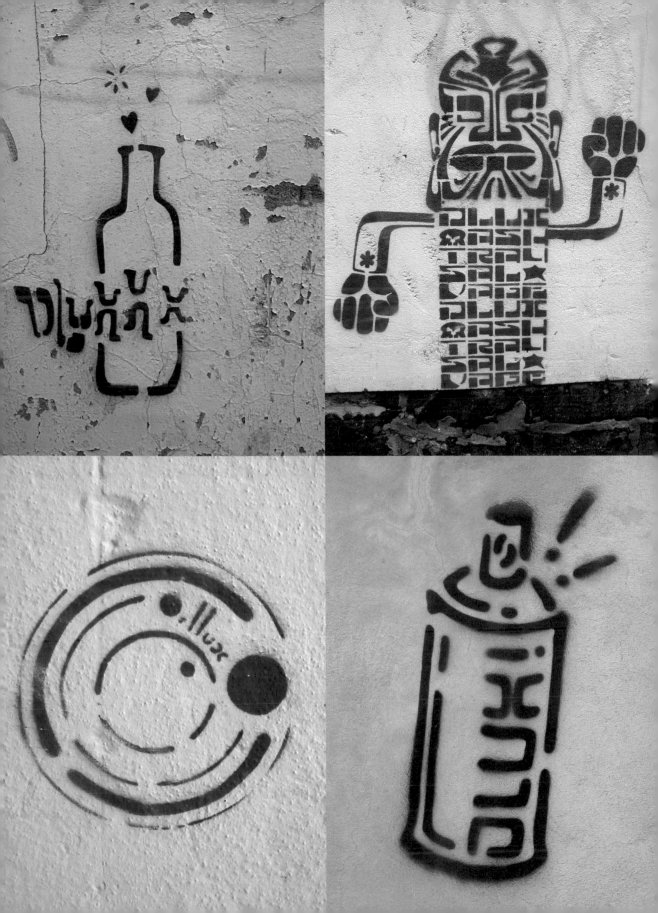

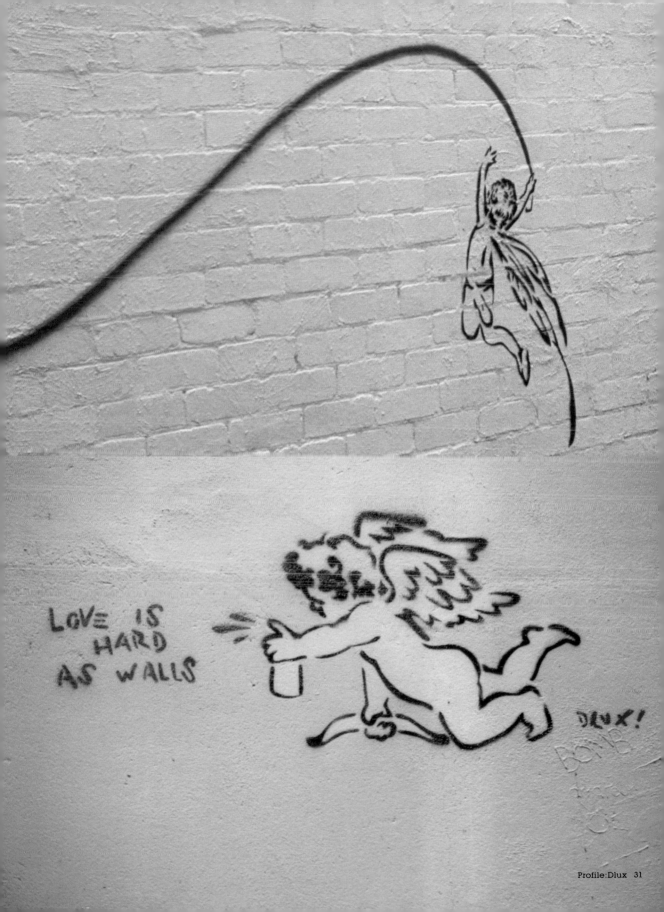

LOVE IS
HARD
AS WALLS

DLUX!

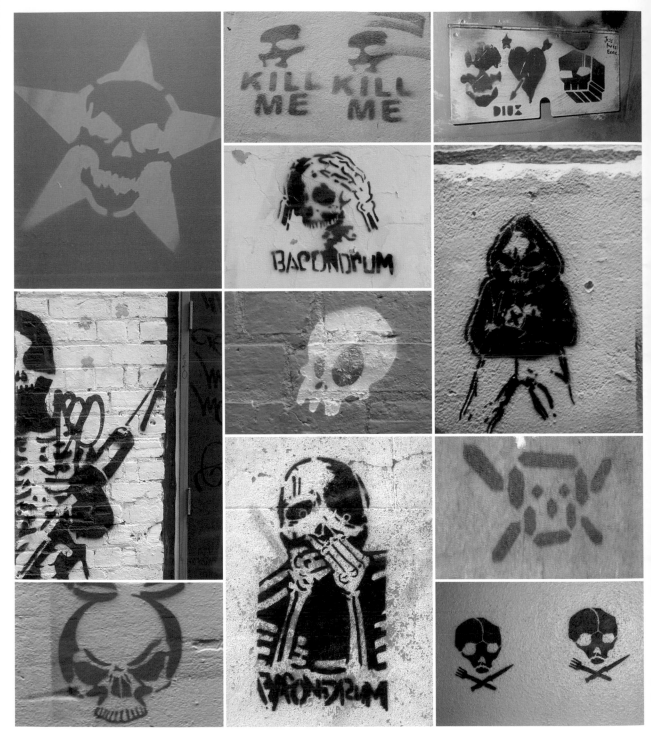

THEME:SKULLS

The skull symbolizes the only certainty in life – death. The image of a skull signals a warning about primal danger, of destruction of the self. Emblazoned on bottles of poison and pirate flags, the skull is one of the most repeated icons stenciled in Melbourne.

The designs vary from humorous to downright disturbing. Some appear to be territorial symbols, while others aim to serve as a warning of society's ills.

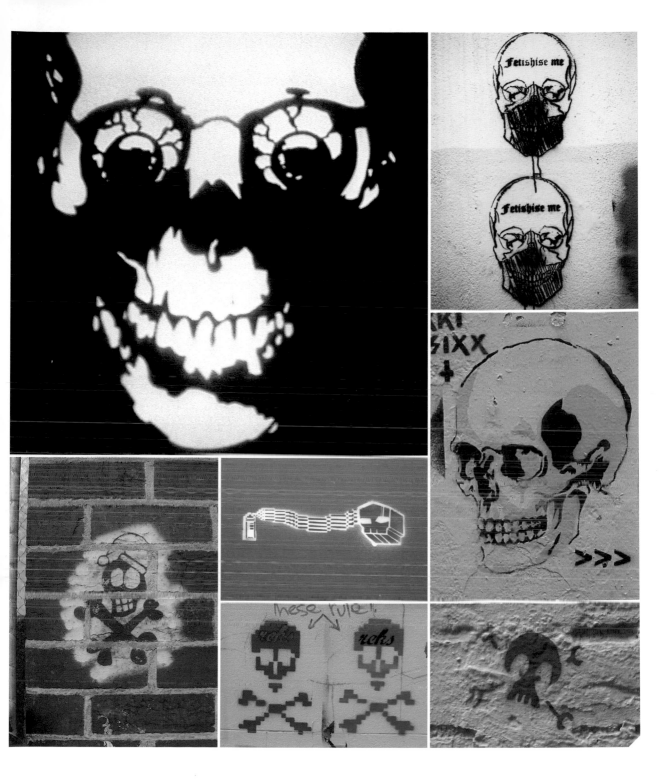

Opposite page, left to right from top: 'Star skull' by Dlux, photo: Mark Mansour / 'Kill me', photo: Satta / 'Two skulls with heart' by Dlux and Civilian, photo: Satta / 'Bacondrum skull' by Bacondrum, photo: Jake Smallman / 'Straight-edge reaper', photo: Shyam / 'Skeleton' by Mted, photo: Mark Mansour / 'Yellow skull', photo: Satta / 'Bacondrum skeleton' by Bacondrum, photo: Satta / 'LCD skull', photo: Satta / 'Skull' by Wallad, photo: Satta / 'Knife and fork skull', photo: Carl Nyman.

This page, left to right from top: 'Grim buffer' by Meek, photo: Jake Smallman / 'Fetishise me', photo: Shyam Ganju, 'Blue skull', photo: Satta / 'Santa skull', photo: Mark Mansour / 'Digital spray skull', photo: Jake Smallman /'Pixellated skulls' by Reks, photo: Mark Mansour / 'Small red skull', photo: Satta.

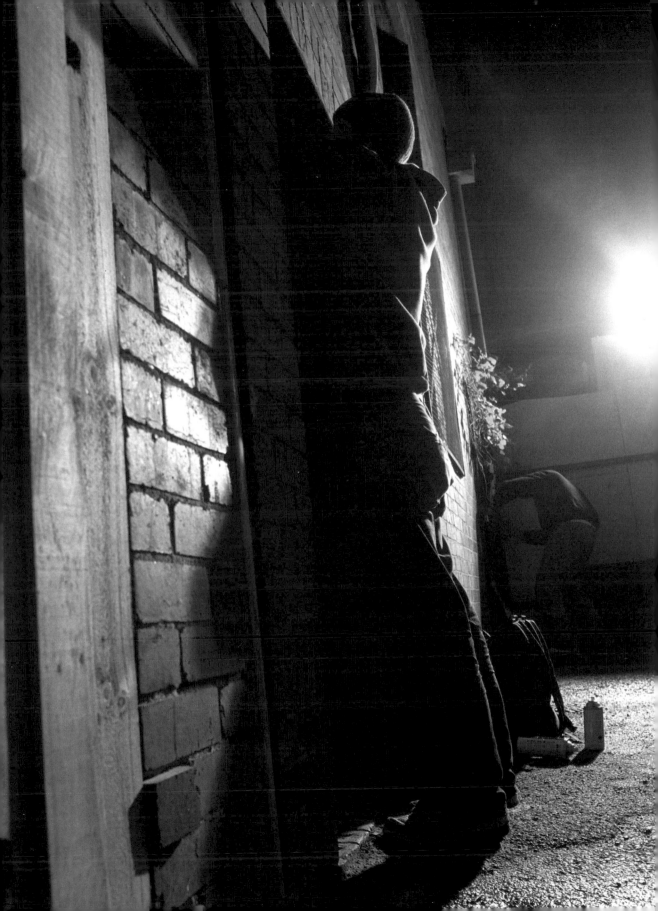

The word "meek" originates from the Bible, meaning "patient and unresentful under injury and reproach." It is also the pseudonym adopted by a twenty-six-year-old street artist in Melbourne: "I see that definition as having relevance to street art because it's really an information war – us versus the ads, signs, billboards etcetera. Street artists are always going to be outnumbered and outgunned, but it doesn't mean we'll stop getting our art out on the streets. I think it's healthy to have some visual ephemera that's not fueled solely by consumerism. I also use the alias Meek because a lot of graffiti is about 'getting-up' – bragging and boasting – so to have a name that means humble is quite ironic in this game."

While living in London, Meek was exposed to Banksy's art and it inspired him to begin doing stencil graffiti. Having studied graphic design, Meek describes himself as having been "a bit of a trainspotter" when it came to street art, but never actually started to put up designs until the start of 2003: "When I got back to Melbourne and saw what was going on here and how many people were making stencils, it really made me want to get some art out on the streets."

Meek's subject matter varies greatly from one piece to the next. "You can't help being inspired by everything around you," he says. "Whether you are happy with your surroundings and celebrate that, or angry and rebel against it, that's up to the individual. For me, I hope it's both. In terms of ideas, I'm inspired by music, especially hip-hop and the way it is a very visually descript music. The use of simile, metaphor and double entendre appeals to me." Meek's "Begging for Change" piece, which features a life-size man begging with a sign that reads, "Keep your coins, I want change," exemplifies his tendency for word play: "That idea actually came from a line in a Jehst song. I put my own spin on it and worked out a way to visually express it." More than a good turn of phrase, it also makes a strong social comment about money and its inability to solve all problems.

"I like my work to have a message, even if it's more personal and not obvious to everyone. To me the best art is the collision of a great idea with a beautiful visual to communicate it. But it is really easy, if you're a visual person, to get caught up in aesthetics and style, and I don't think that should be frowned upon either. One reason I love street art is because it is what it is. Whether it's a simple idea or the idea is simply style, it doesn't pretend to be something it's not. The average person on the street can take something from it without needing to understand the whole history of 20th-century art."

"Most of my stencils are designed with the thought that the average person in the street will see them and hopefully think about it, so they go all over the streets of Melbourne, anywhere I can paint them without too much risk of getting caught. At other times I will create a design that is more visual than conceptual. There's still always an idea that I am exploring, but sometimes it is more an exercise in trying to create something that looks unique. I guess this type of stencil is created more for people interested in visual art, rather than trying to arrest the attention of the average passer-by."

Meek has also used stickers, wheat paste and even hijacked a billboard in order to convey his art to the public, but always returns to stencils: "I think stencils are a form of graffiti that is able to communicate with the general public, not just other writers. I have always been more into the mechanical arts, like photography, screen printing and digital design, rather than drawing and painting, so using stencils was an obvious choice for me. If I could draw really well, I might do more freehand graff, but using stencils lets me use photography and the computer to realize my ideas. I also love the aesthetic of the stencil, the hard edge, the texture of the wall and also the permanence."

According to the Bible, the meek are supposed to inherit the earth: "I'm sick of waiting, I'll just fucking take it now, one wall at a time."

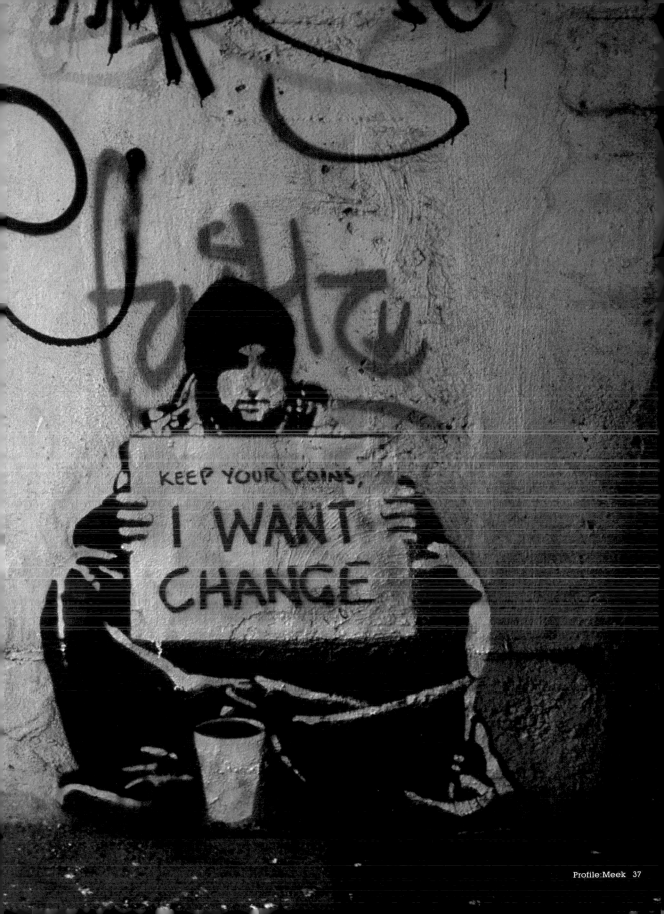

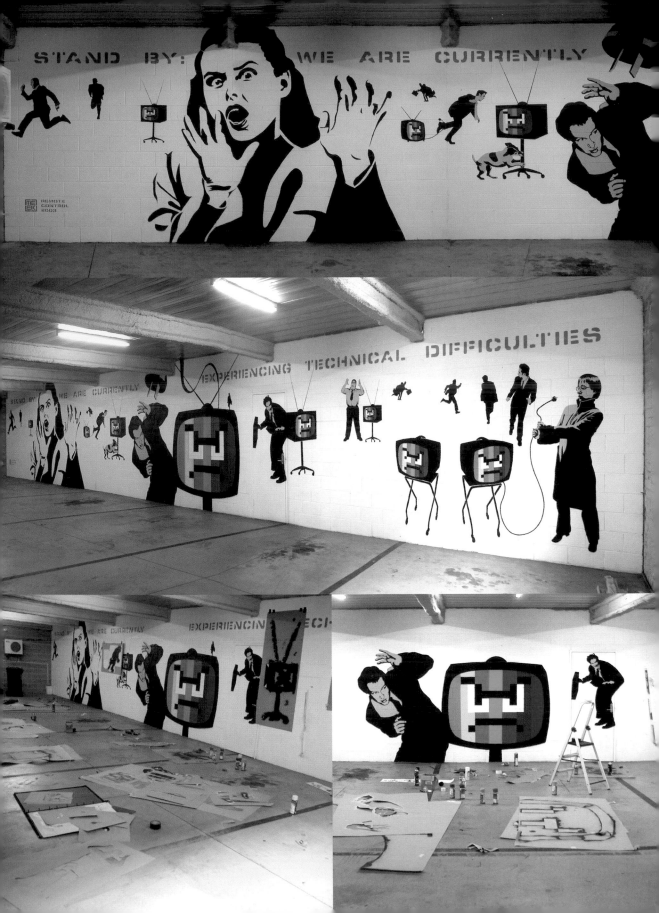

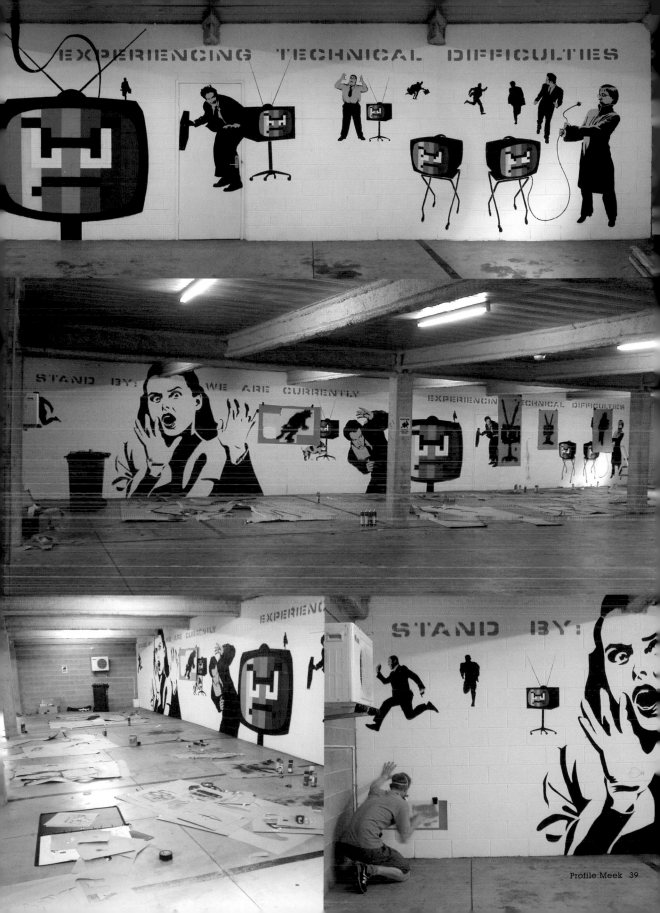

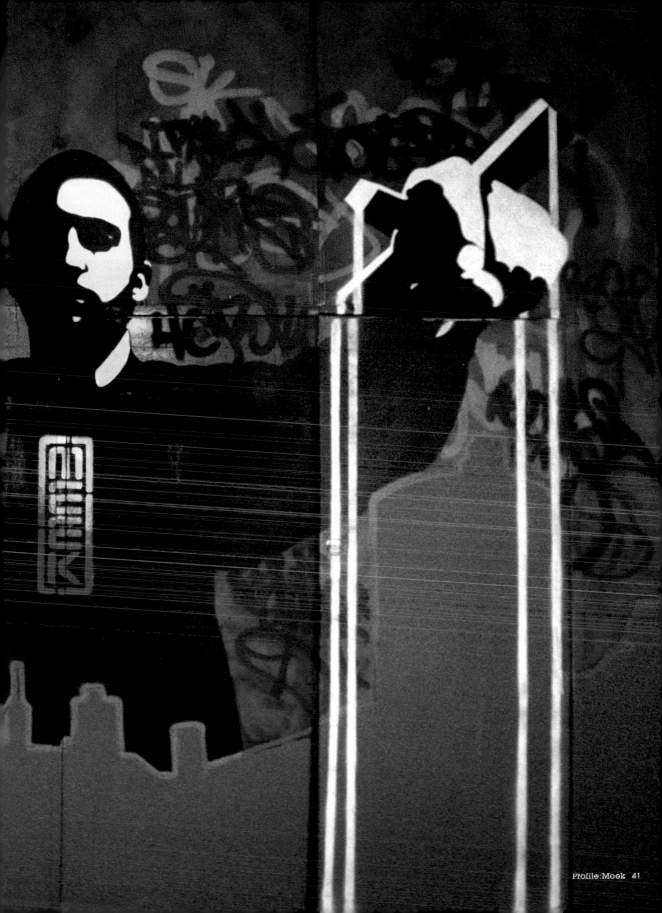

This wall has been
intentionally left blank.

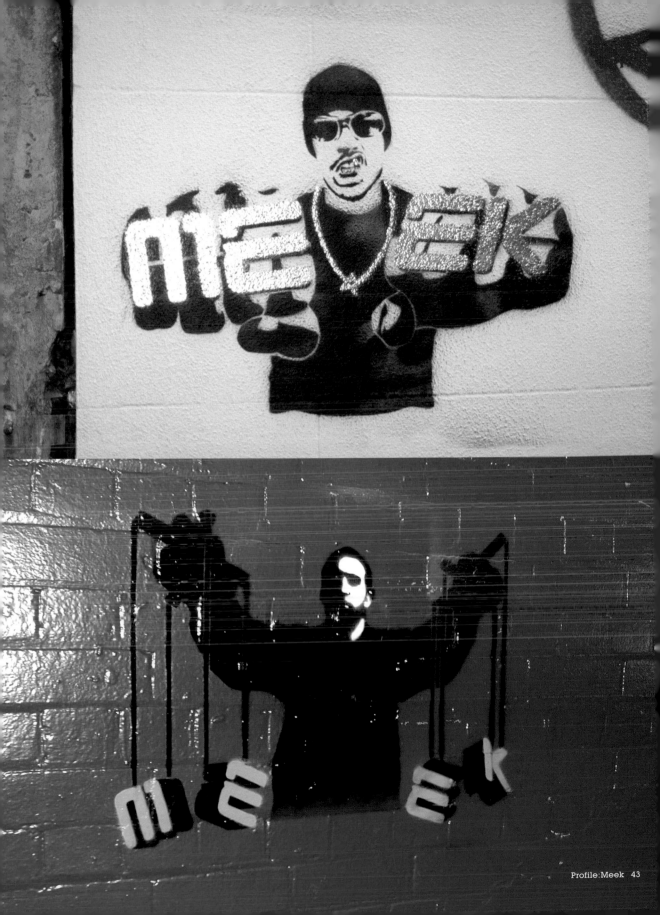

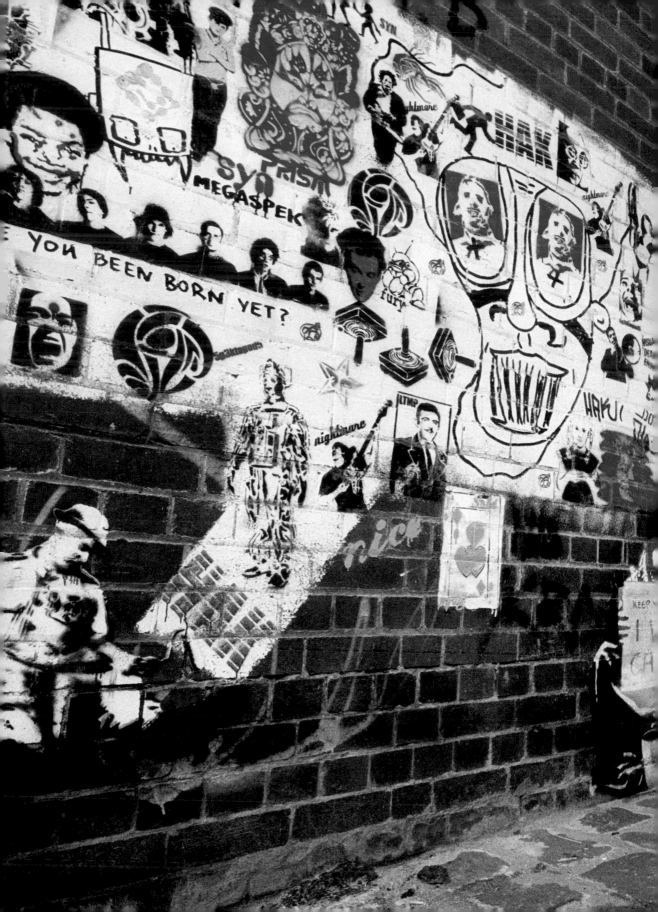

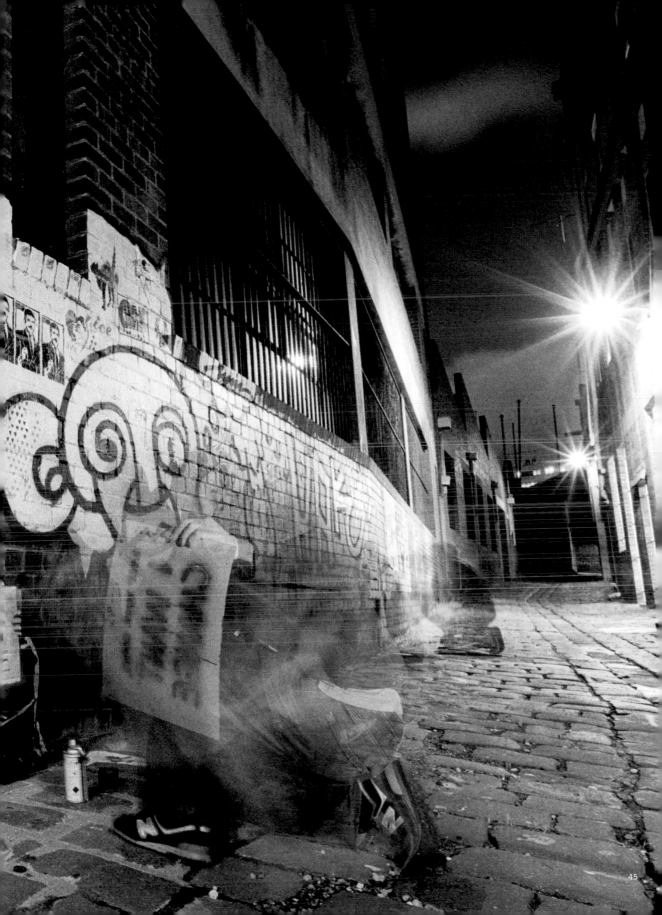

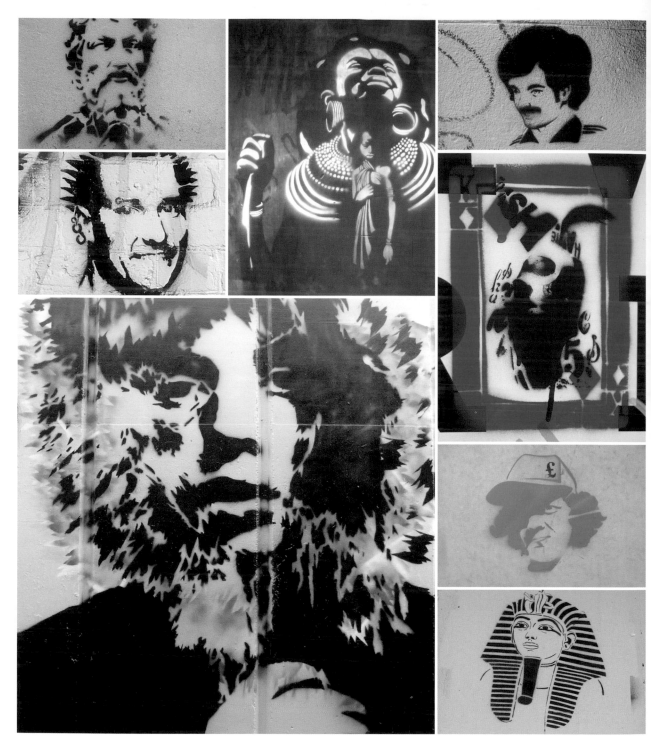

THEME:FACES

If it's not of a political message, chances are an artist's first stencil is a face. Happy, sad, angry, scared, our faces express what we feel. Painted on a wall they broadcast the emotions and attitudes of the person who put them up, widening the reach of a smile, the angst of a tear and the emptiness of a blank stare.

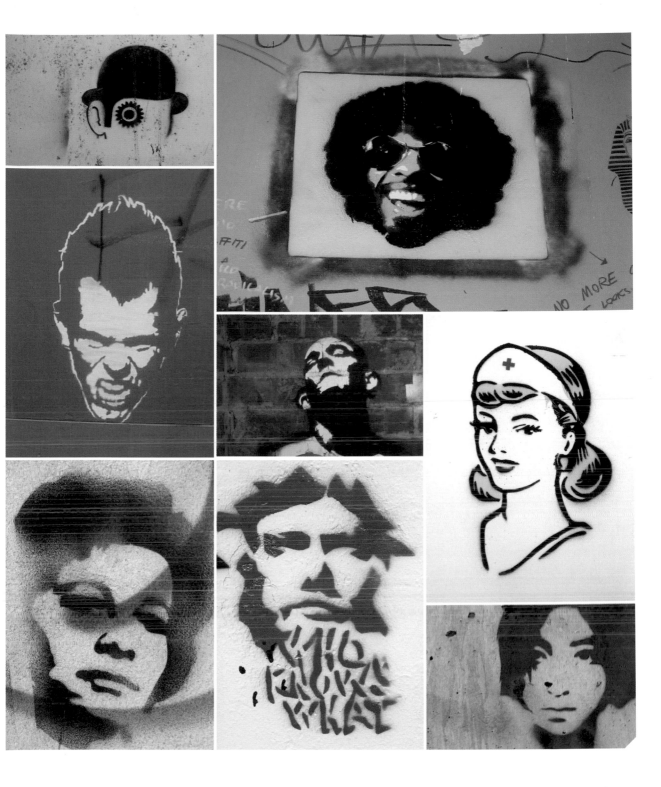

Opposite page, left to right from top: 'John the Baptist' by Dominic Allen, photo: Mark Mansour / 'African woman' by Satta, photo: Peter Casamento / '60's guy', photo: Mark Mansour / 'Norwegian prince' by Dolk, photo: Jake Smallman / 'King', photo: Peter Casamento / 'Hooded face' by LTMP, photo: Amac 1 / 'Self portrait' by Pound, photo: Jake Smallman / 'Pharoh', photo: Satta.

This page, left to right from top: 'Clockwork orange', photo: Mark Mansour / 'Sly Stone', photo: Satta, 'Screaming face' by Anton, photo: Carl Nyman / 'Far far' by Sixten, photo: Carl Nyman / 'Nurse' by Ando, photo: Ando / 'Blue face', photo: Peter Casamento / 'Who knows what', photo: Peter Casamento / 'Asian face', photo: Carl Nyman.

In 1999, you were lucky to spot a stencil in the streets of Melbourne and if you did, chances are it was painted by Psalm, hard to believe now given the overwhelming number of stencils that invade every unused space in the city today. "It's not long ago at all, when you think about it," reflects the quiet-spoken Psalm, a man who has undoubtedly inspired many others to adopt the technique. "I just hope to inspire other urban artists to get out there, be creative and push the boundaries of whatever they're doing."

Psalm's street stencils are usually monochromatic, quite small and very detailed. From religious imagery like monks and angels, to Japanese cartoons and pop art, Psalm's subject matter borrows heavily from the history of visual art. The power of Psalm's work is grounded in how he reworks and recontextualizes the past into the contemporary medium of stencil graffiti. Perhaps because of his background in graffiti, which is primarily concerned with letters, he is also able to find new and interesting ways to incorporate his moniker into each of his stencils. The flow of his letters is always well considered and is designed to work with the style of each particular visual.

"I've been involved in graffiti for well over 10 years now, but I've become a bit disillusioned with the whole politics of graff and the enormous egos associated with it. So I thought I'd explore other avenues of urban art. Stenciling is an evolution of tagging but without the graff mentality, so it was pretty much a logical progression for me. I enjoy this medium because it's quick, can be done in a variety of places and, most importantly, you don't need any can control. I like the way images can be formed by using positive and negative areas. It also attracted me because it's a relatively new area of urban art here in Melbourne and there's a lot more growing to do."

"I paint in the city or surrounding suburbs. I use these areas for two main reasons. Firstly, it provides me with far more exposure than I could ever get from the suburban environment. Just look at Brunswick Street, for example. During the day you have a constant flow of workers, shoppers, cafe dwellers, etcetera. During the night you get another flow of people coming to see bands, have dinner or hang out. Therefore, I have the ability to expose just about every demographic of person to my work and I've only concentrated on one part of Melbourne. Secondly, I choose the inner city setting for the simple fact that there's a greater variety of walls and places to put work up on."

"I try to stay away from public property because if you get busted there is no bargaining power, you're going down no matter what. I can't understand the fact that you could possibly be sent to jail for such a trivial thing. I suppose the law is good because in one sense it sets a definitive boundary that you can overstep. In essence, you're smashing boundaries. I really couldn't care less about a bunch of pompous old farts and their arcane policies. They should pull their heads out of their own arses and take a look at the real problems in society. Anyway, I'm having fun and being creative, that's all that matters to me."

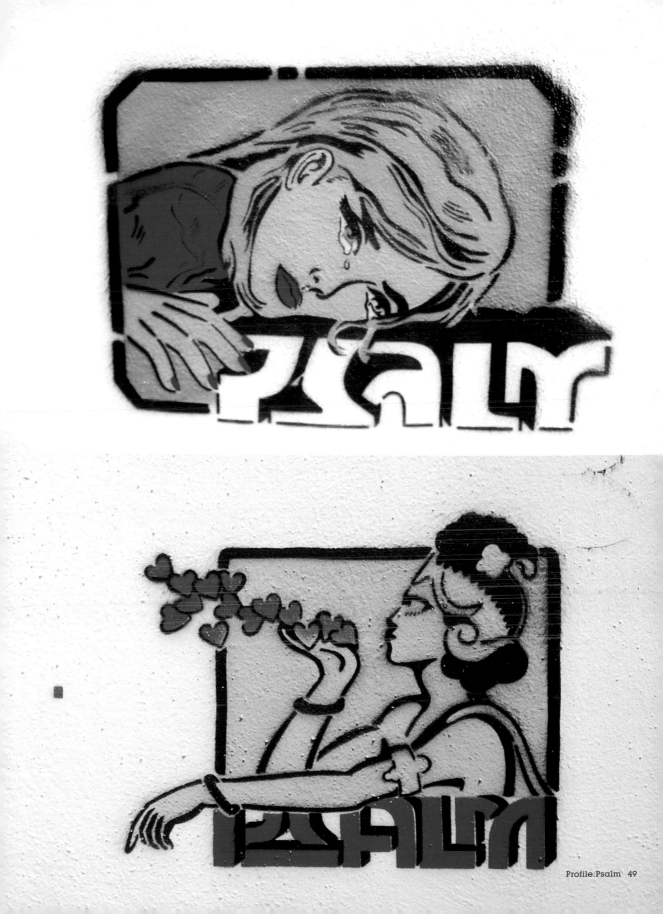

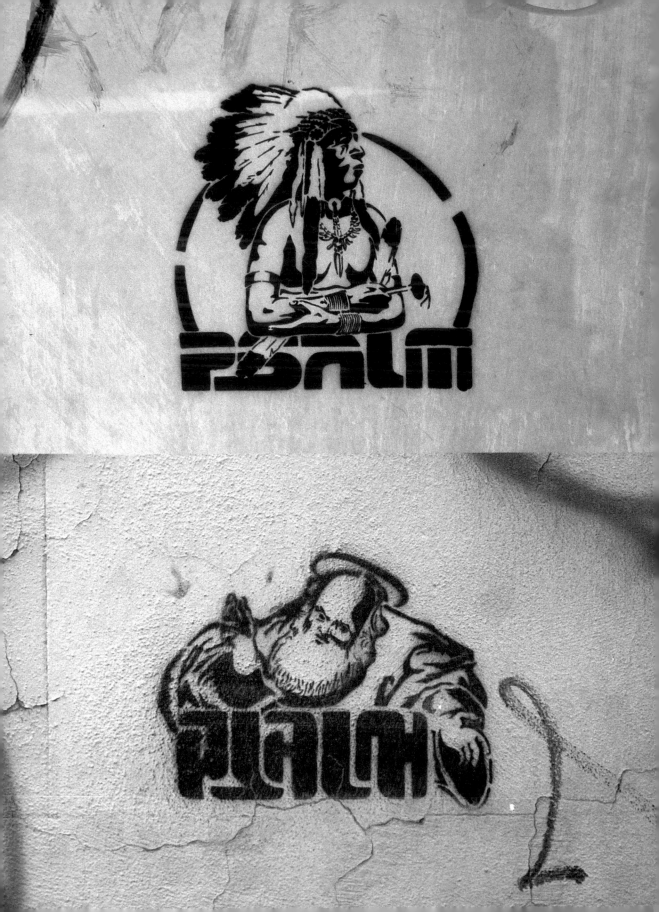

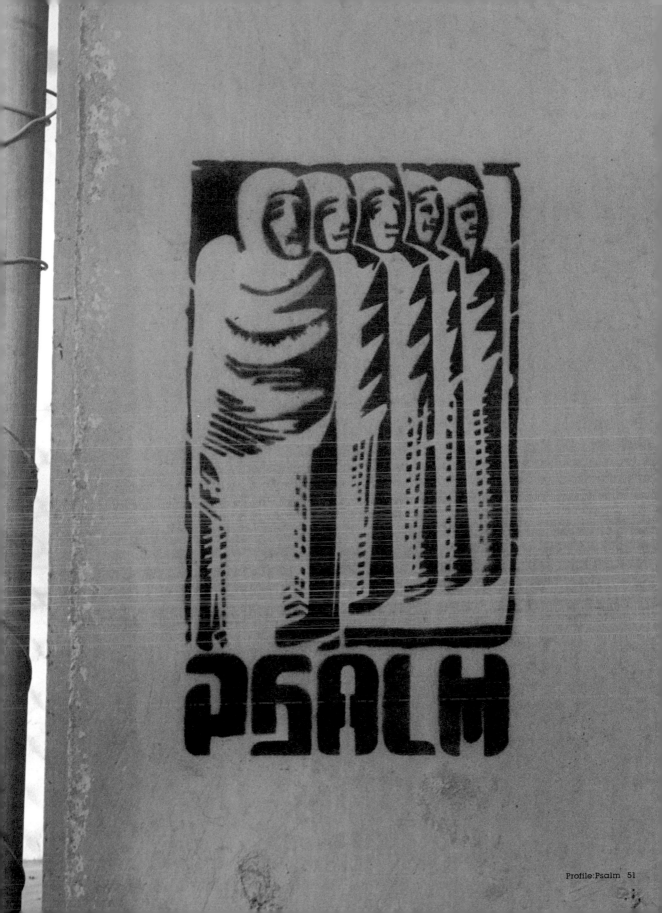

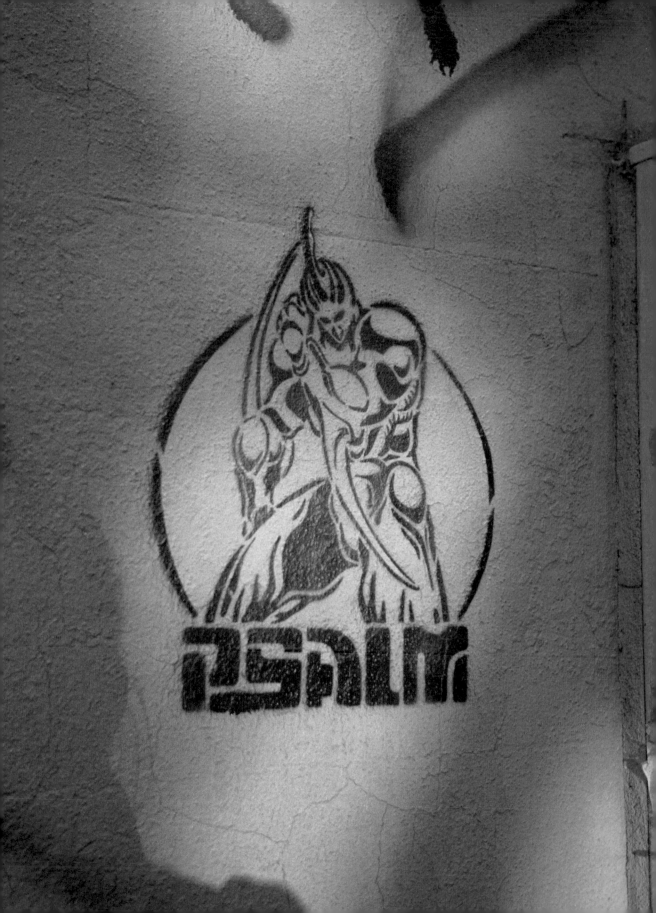

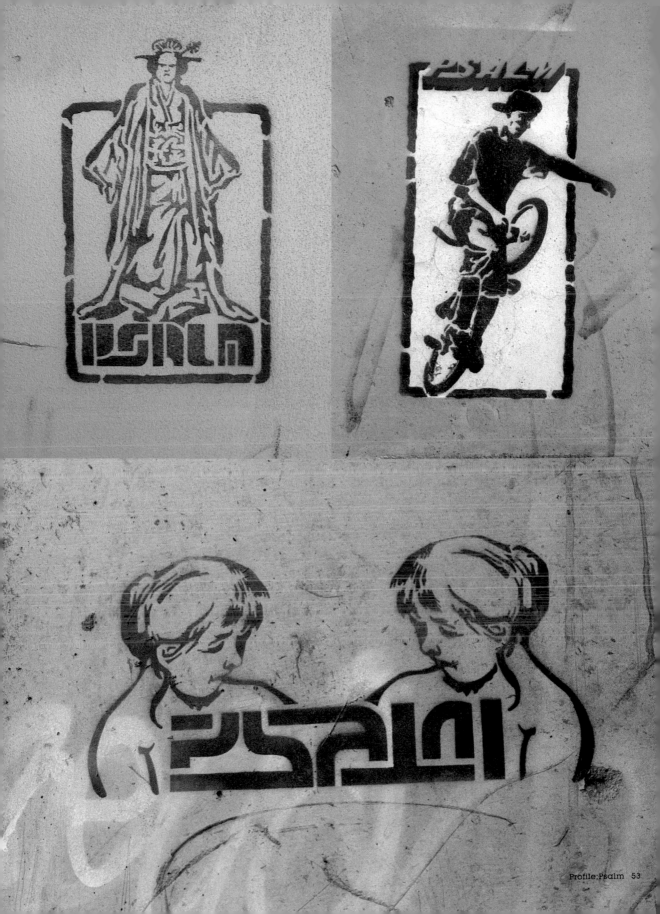

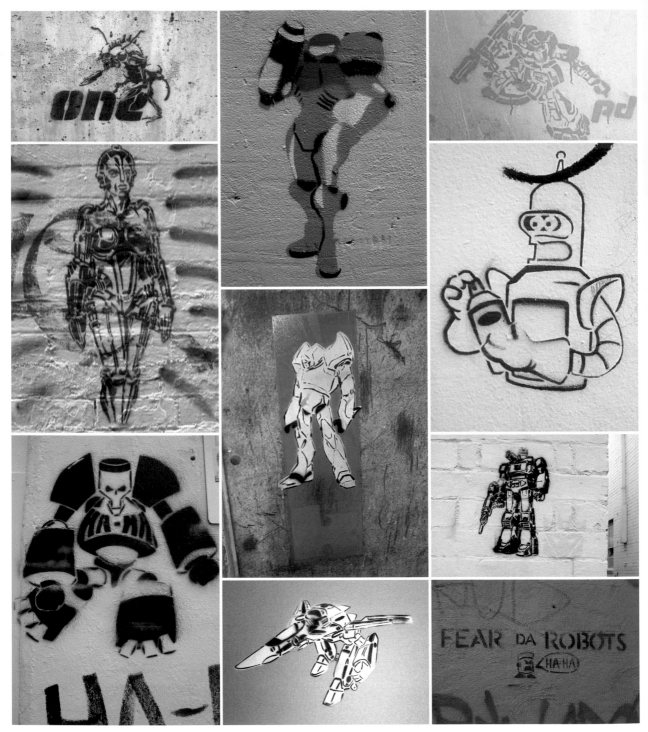

THEME:ROBOTS

Robots and their mechanical creature cousins
return many stencil graffiti artists to their childhoods.
Transformers, the toys of choice for kids growing up
in the 1980s, remain a point of interest and inspiration
today for street artists who appreciate the lines of the
high-tech Japanese designs. The older robots have
a retro appeal that represents outdated notions about
how designers thought the future would look.

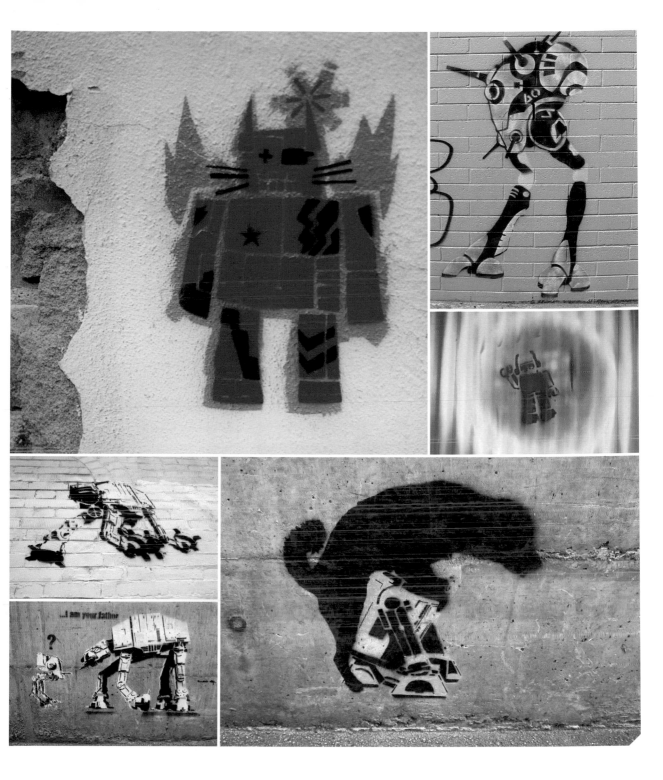

Opposite page, left to right from top: 'One' by Satta, photo: Jake Smallman / 'Samus Aran' photo: Mark Mansour / 'Transformer' by PD, photo: James Dodd / 'Metropolis' by Wallad, photo: Satta / 'Bender', photo: Satta / 'Mech' by Koan, photo: Jake Smallman / 'Transformer' photo: Carl Nyman / 'Ha-Ha Robot' by Ha-Ha, photo: Mark Mansour / 'Transformer plane' by Monkey, photo: Carl Nyman / 'Fear da robots' by Ha-Ha, photo: Jake Smallman.

This page, left to right from top: 'Robot cat', photo: Shyam Ganju / 'Bi-ped' by Button Monkey, photo: Mark Mansour / 'Small robot', photo: Mark Mansour / 'Imperial Walker', 'I am your father' and 'R2D2' all by Dolk, photos: Jake Smallman.

MELBOURNE STENCIL FESTIVAL

Conceptualized as an event that would develop and encourage discussion and appreciation of stencil art, the Melbourne Stencil Festival sought to widen audiences of the medium both in Melbourne, the rest of Australia and the world. It was, as organizers Satta and J.D. Mittman explain, "important to place the art in a wider socio-political context and nurture debate and community participation."

In February 2004, the Melbourne Stencil Festival launched with a tremendous public reception at a former textile factory. There were two components to the main exhibition: an invitation-based show and an open-entry show. Nineteen of Melbourne's most prolific stencil artists exhibited their work and 30 other artists submitted work to the open exhibition. In total, the 2004 Melbourne Stencil Festival featured more than 200 works on materials ranging from canvas, metal and plywood to street signs and skateboards. Almost half of the works exhibited were sold; many artists took home nothing more than a check.

The 2004 Stencil Festival was about much more than selling art. No better were the social implications of street art brought to light than during the debates that focused on aesthetic appeal and legality, argued by city council members, artists and appreciators. No doubt, such dialogue was an important step in developing an increased acceptance and understanding of the art form.

The success of the 2004 festival consequently led to the development of a bigger and better festival in 2005. Again J.D. Mittman and Satta spearheaded the event, securing funding through an Arts Grant from the city of Melbourne. Held at North Melbourne's "Meat Market," the newly renovated meat distribution factory had recently re-opened as one of Melbourne's newest public contemporary art venues.

The 2005 Melbourne Stencil Festival presented over 270 works by 87 artists to an even larger portion of the public. More than half of the artists were international and represented the United States, Brazil, Germany, the United Kingdom, Denmark, Sweden and New Zealand. Alongside the international array of already established artists, the 2005 Stencil Festival included a new exhibition category: Under 18.

Between the artists from afar and the youngsters from the neighborhood, it was clear that the past year had been one of growth for stencil art, particularly in terms of its popularity.

As a result of its rapidly growing reputation, the opening night of the 2005 festival drew nearly 1,000 people, including guest-of-honor Penny Hutchinson, Director of Arts Victoria. Compared to the previous year, the 2005 Stencil Festival was clearly on display as a publicly sanctioned event. A positive change in terms of event funding and sales of the artwork, many artists found the festival's affiliation with the "institutions" and corporate sponsors compromised their stencil art and street culture ideals. This schism, however, spurred another panel discussion titled "Sold Out – The Future of Street Art."

Because of this growth in the popularity of the art form, it became important to provide the space for the definition of stencilling to be extended in the public eye – to be broadened and re-defined in order for it to continue to develop. Paste-ups and stickers were included in the 2005 festival with an exhibition titled "Black 'n' White – Paper Ninjas." Showcasing the work of a dozen artists, "Paper Ninjas" included large-format paste-ups, character designs, posters, stickers and cartoons, reflecting the street and "traditional" graffiti more closely than the hung exhibit and illustrating the crossover of stencil art into other parts of street art culture.

Despite controversy, the Melbourne Stencil Festival has acted as a celebration of stencil graffiti, and has witnessed and represented the changes to the culture within which it operates. It has taken part in creating yet more debate, while exposing established and emerging artists' work and the evolving development of stencilling as an art form to the wider community, particularly in an "off the streets" context.

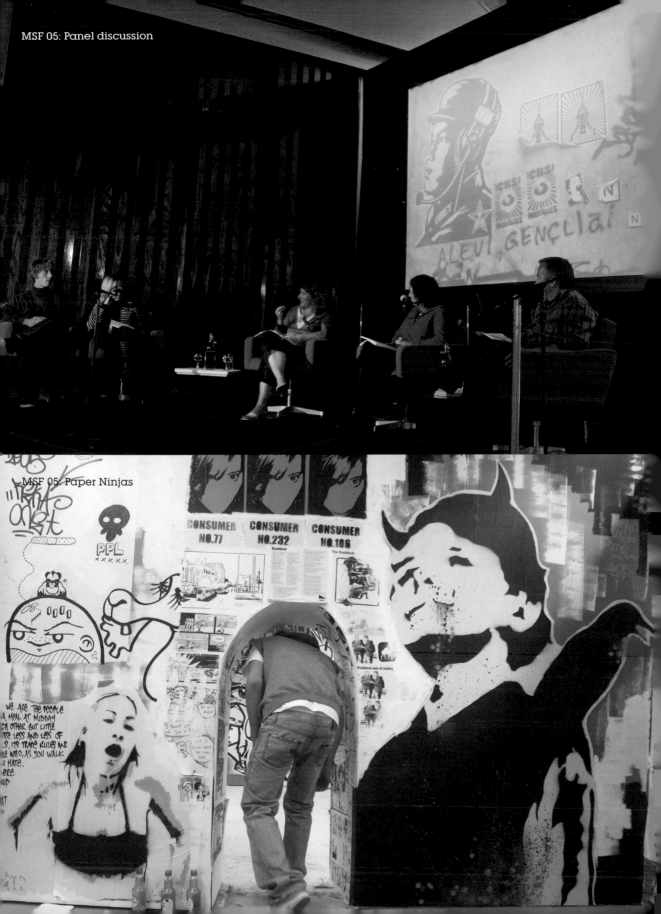

MSF 05: Panel discussion

MSF 05: Paper Ninjas

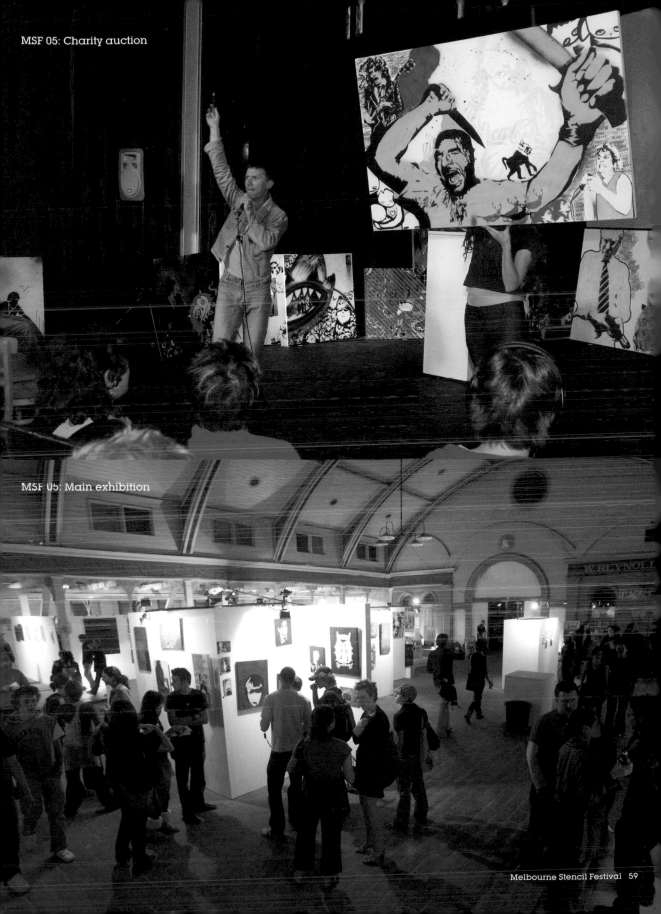

MSF 05: Charity auction

MSF 05: Main exhibition

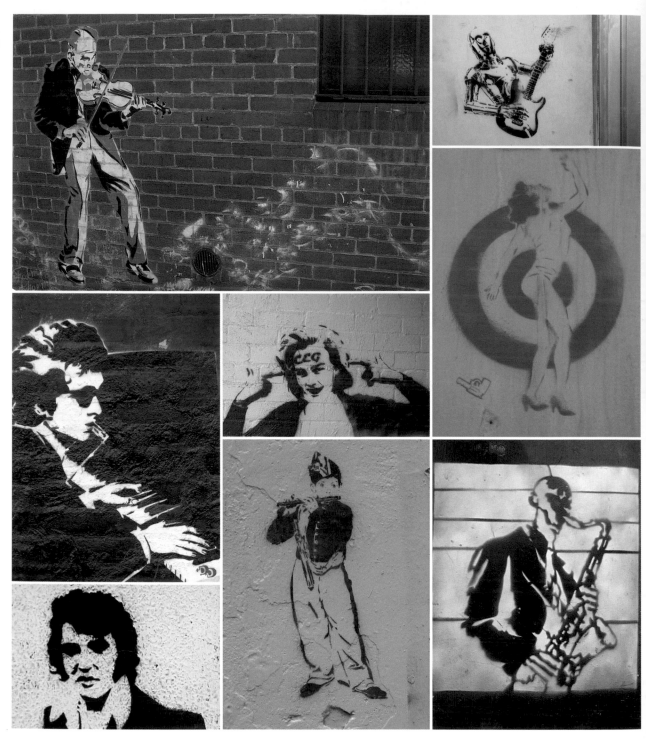

THEME:MUSIC

Music surrounds us every day. It inspires, motivates and helps us relax after a busy day's work. Artists often depict their favorite musicians to pay homage to the work of their idols. While traditional graffiti has a strong foundation in hip-hop, stencils of classic icons and contemporary stars reflect the wide range of people involved in stencil graffiti.

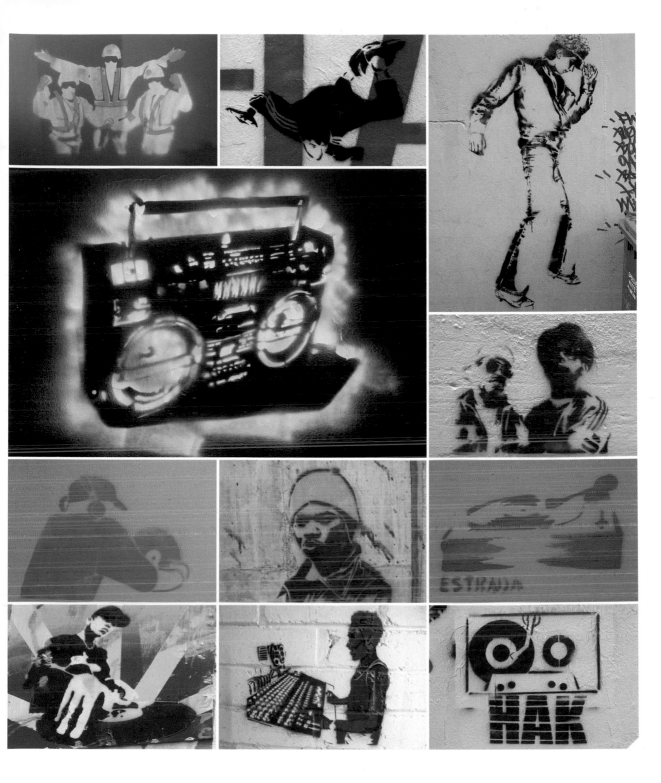

Opposite page, left to right from top: 'Violinist' by Form, photo: Mark Mansour / 'C3P0', photo: Mark Mansour / 'Piano man' by DD, photo: Mark Mansour / 'Not listening' by CEG, photo: Mark Mansour / 'Kylie', photo: Satta / 'Elvis', photo: Satta / 'Flutist', photo: Satta / 'Saxophonist', photo: Carl Nyman.

This page, left to right from top: 'Beastie Boys' by Monkey, photo: Jake Smallman / 'B-boy' by Ha-Ha, photo: Mark Mansour / 'B-girl' by CEG, photo: Mark Mansour / 'Ghetto blaster' by Rone, photo: Jake Smallman / 'Addidas Bruddahs' by Button Monkey, photo: Satta / 'DJ', photo: Mark Mansour / 'Ghostface Killa' by Optic, photo: Jake Smallman / 'Turntable' by Estrada, photo: Satta / 'DJ Qbert' by Rype, photo: Mark Mansour / 'Lee Scratch Perry' by Satta, photo: Mark Mansour / 'Tapedecks' by Hak, photo: Carl Nyman.

"Through Stencil Revolution I came in contact with Prism, who helped me get over here to Melbourne. Basically we just scammed the Swedish government out of a grant, allowing me to do anything I wanted for six months, all expenses paid. I'm a government-sponsored vandal, believe it or not."

Sixten did his first stencil in 1994 on a skateboard but it wasn't until six years later that he got involved in street art: "I started out doing stickers and posters visually inspired by WWII-era Nazi and Communist propaganda posters. Mine, however, were advocating anarchy and love."

Drifting into stencils his subject matter changed but his ideals remained the same: "The very act of doing street art is a political statement, whether intended or not. It's a way of saying that you are unhappy with your surroundings, a reaction against the norm. When you can no longer accept what's going on around you, you either work to make it better or destroy it completely. With art you can do both."

With his stencils Sixten hopes that his images will spark some sort of reaction in the viewer. His messages range from the blatant and obvious to the subtle and, he admits, farfetched: "Like the 'Jesus Shaves' image, for example. To most people it's just a play on words and a funny image. But the idea actually came to me when the US first invaded Afghanistan, in a time when anyone from the Middle East sporting a beard was considered a terrorist. Eventually people started shaving to get away from the stereotype. Jesus, as everyone knows, was from the Middle East. Jesus saves, Jesus Shaves."

Back in Sweden, Sixten rarely used his stencils more than once: "The town I lived in was pretty small and I didn't want to overdo it. I'd rather work with the surroundings and try to find the perfect placement than just put-up everywhere. That way I think people appreciate it more as art than vandalism." It's a tactic that seems to work as he claims to only have been buffed once, in a town where tags and throw-ups get buffed within days.

Since coming to Melbourne his approach has changed quite a bit: "Melbourne is a much larger city and you can put-up a lot more without really overdoing it. Bombing with people like Ha-Ha has definitely had an effect on me too. Nowadays, I'll paint more or less anywhere."

"I want an audience for my art and prefer spots with high visibility. But of course you always have to calculate the risks. I've never been caught and don't intend to, although I think that if you keep doing it long enough they will eventually get you. It doesn't bother me much though."

Like many other stencil artists, Sixten doesn't limit his paintings to the streets. His work has been on display on a number of occasions, in both Melbourne and Sydney as well as in Europe and the United States.

"Lately I've been doing a bit more complex designs and have been working a lot with drips and splatters, especially for off the street stuff. But I still prefer a simple clean one-layer stencil on the street to a complicated multi-layer piece on canvas. I really like the iconic image that one-layer creates and how it grabs your attention as you walk by."

Along with some of the other artists covered in this book, Sixten has used the Blender Studios as his base: "The time here has been a great inspiration. The place vibrates with creativity and the amount of talent is just disgusting. Along with the people, this place is definitely what I'll miss the most when I return to Sweden."

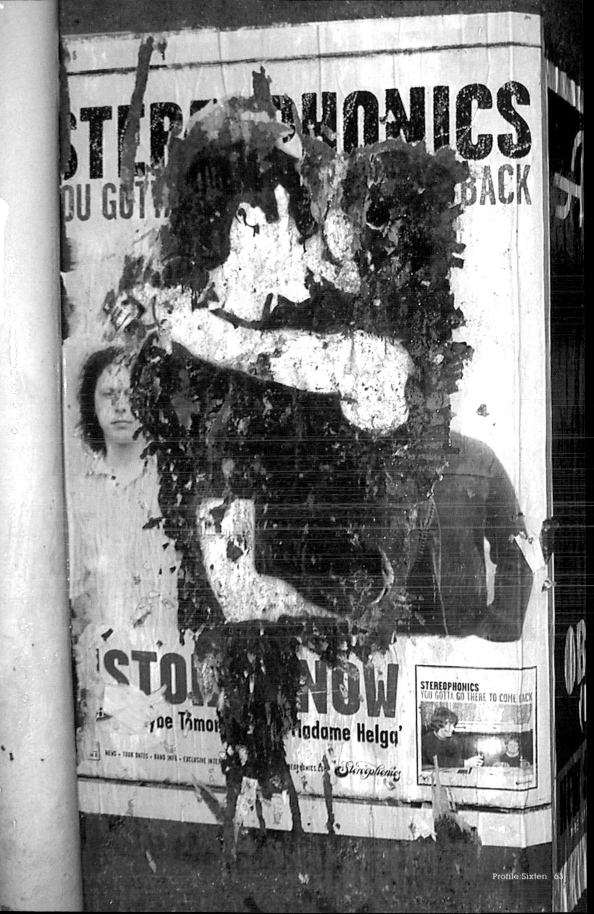

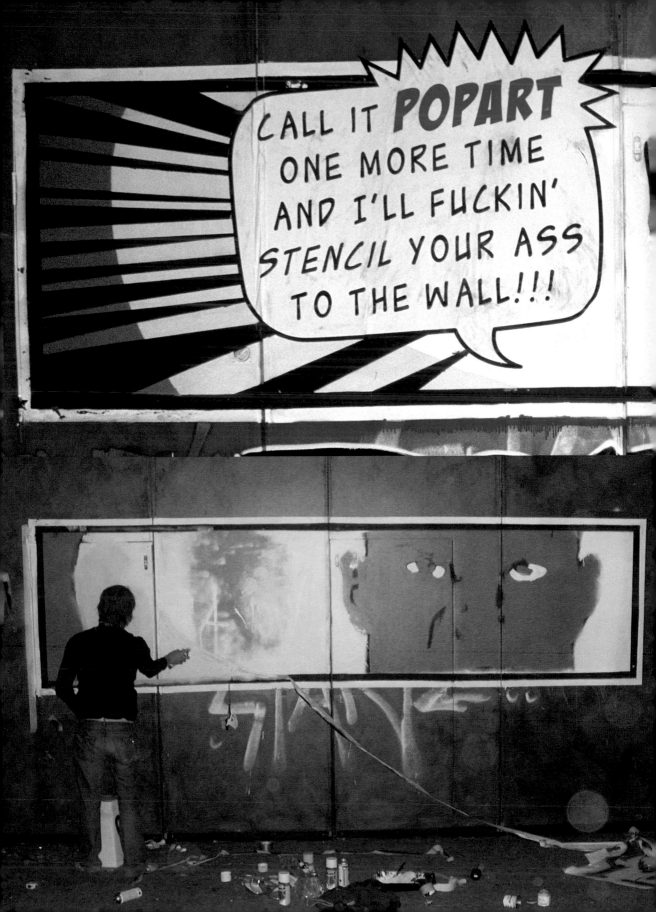

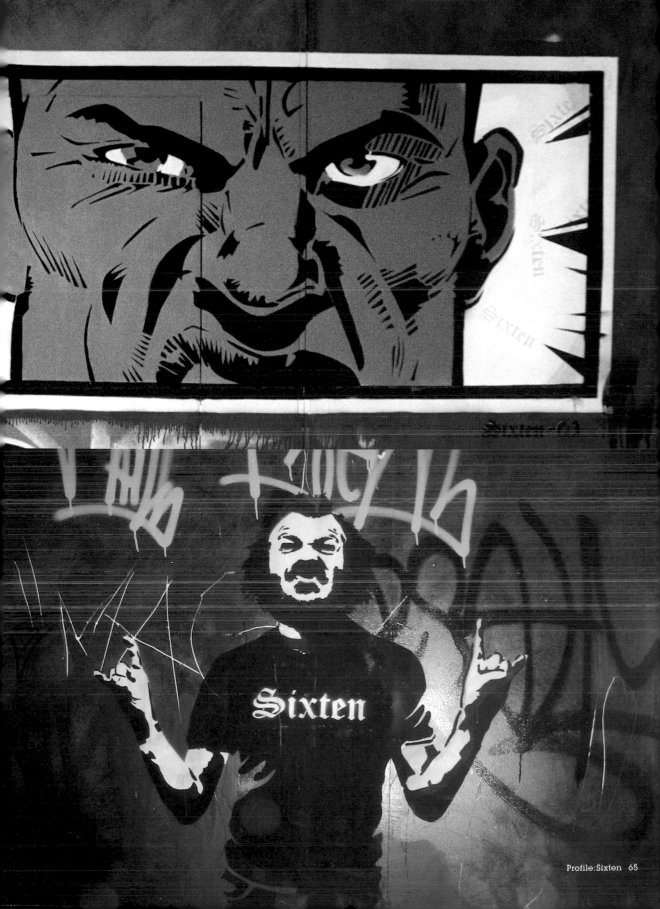

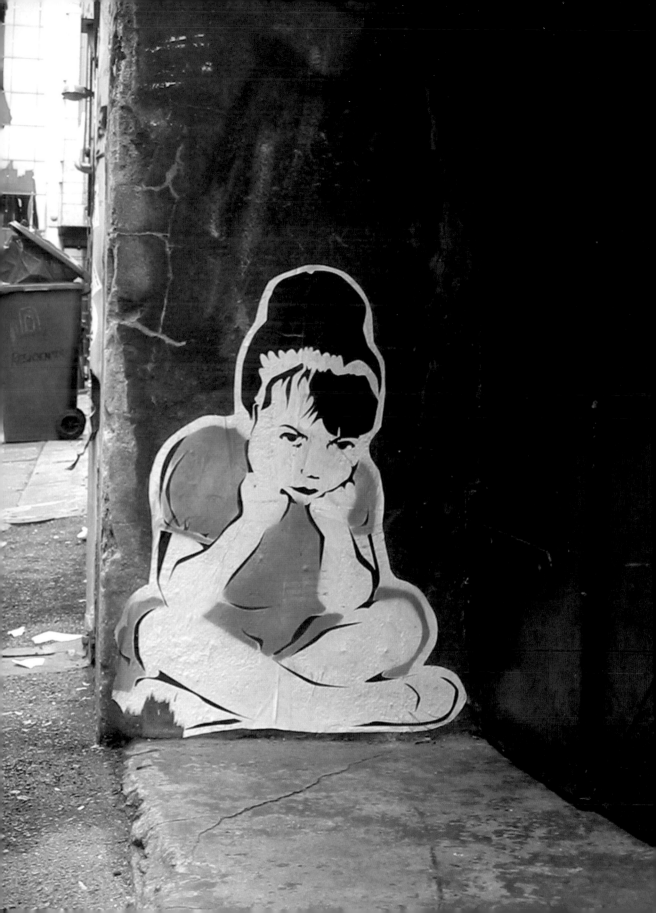

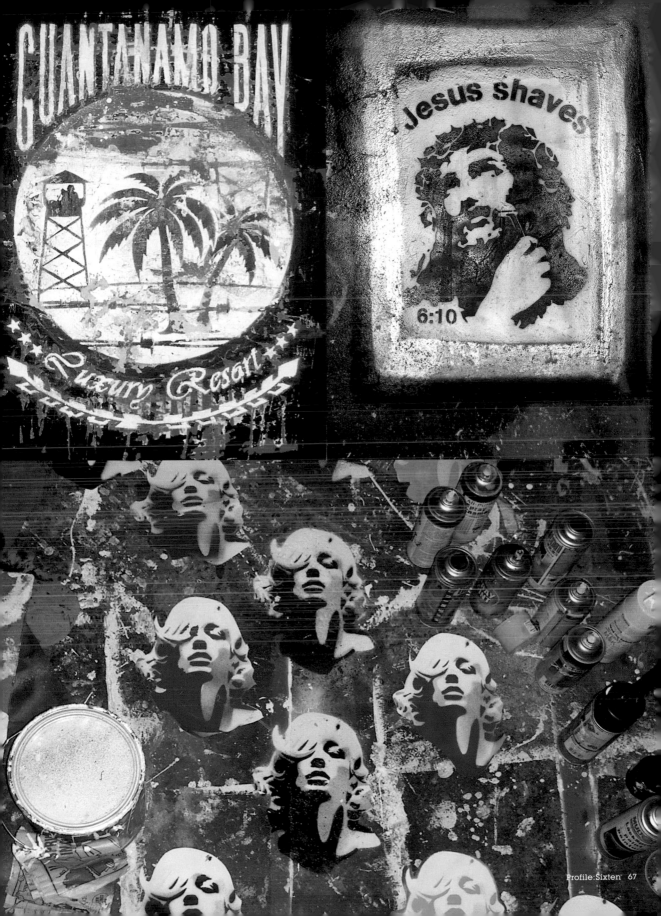

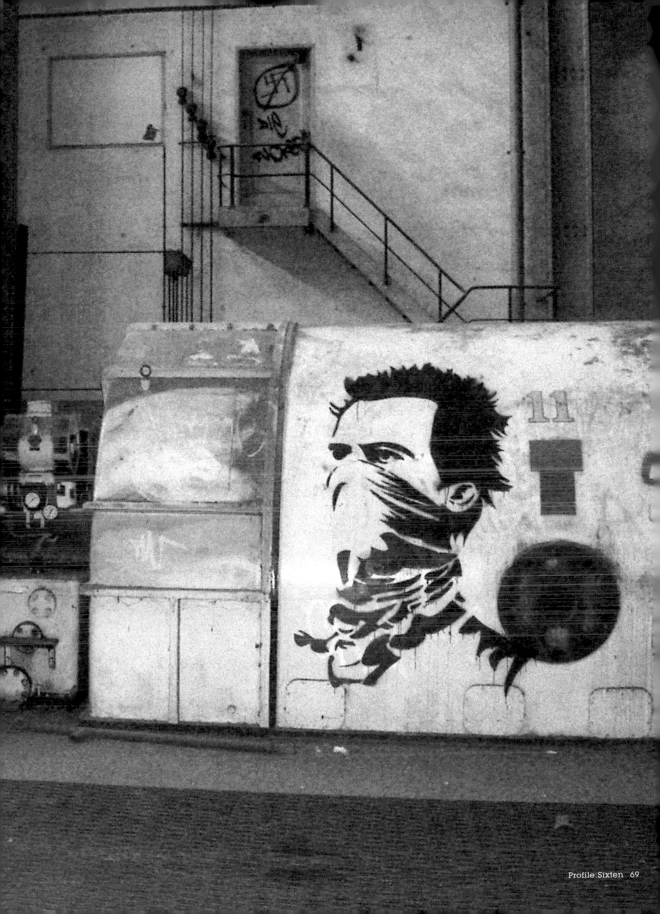

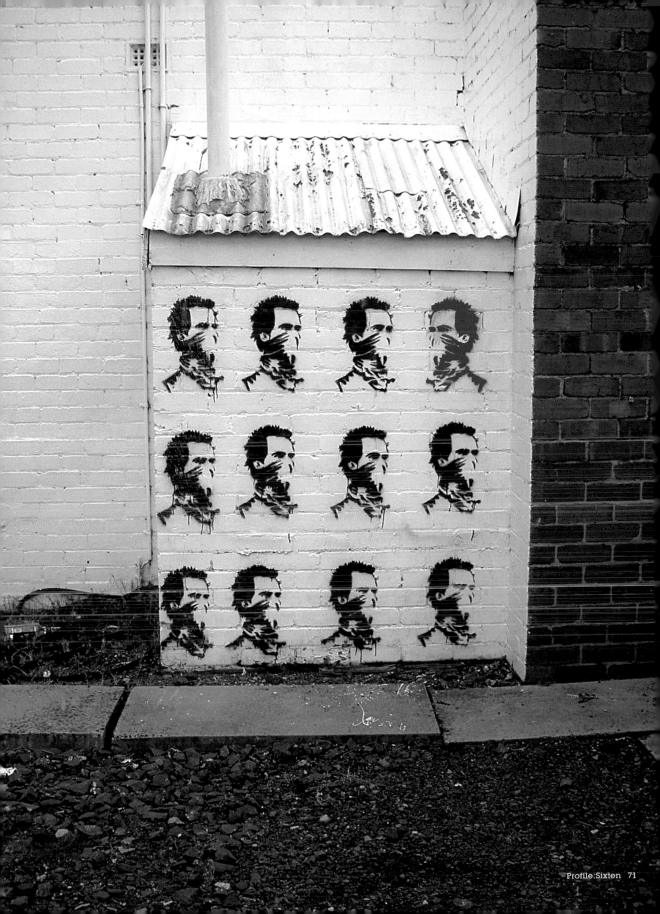

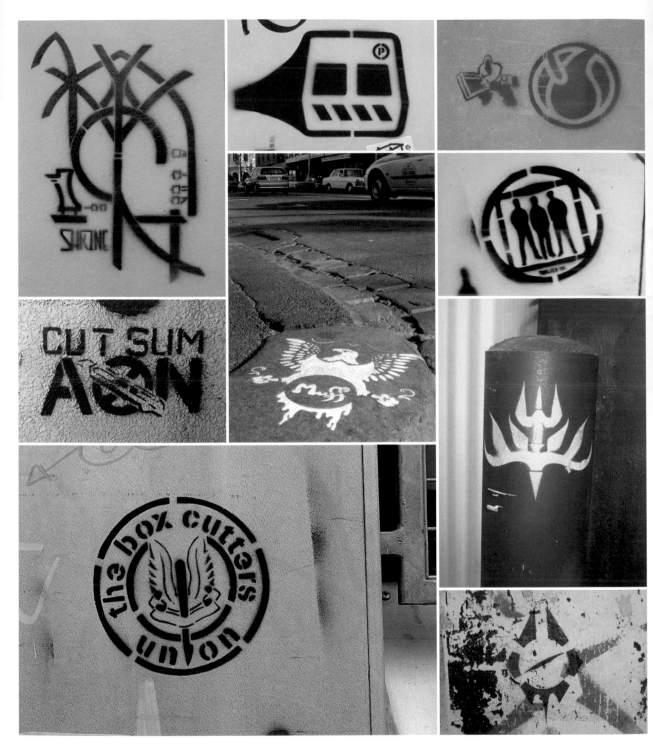

THEME:SYMBOLS

Simple, clean, monochromatic, iconographic and symbolic, these designs lend themselves perfectly to the stencil technique. In a move that replicates, or perhaps more accurately, retaliates against advertising, artists stencil logos and symbols to put their names and ideas out into public spaces.

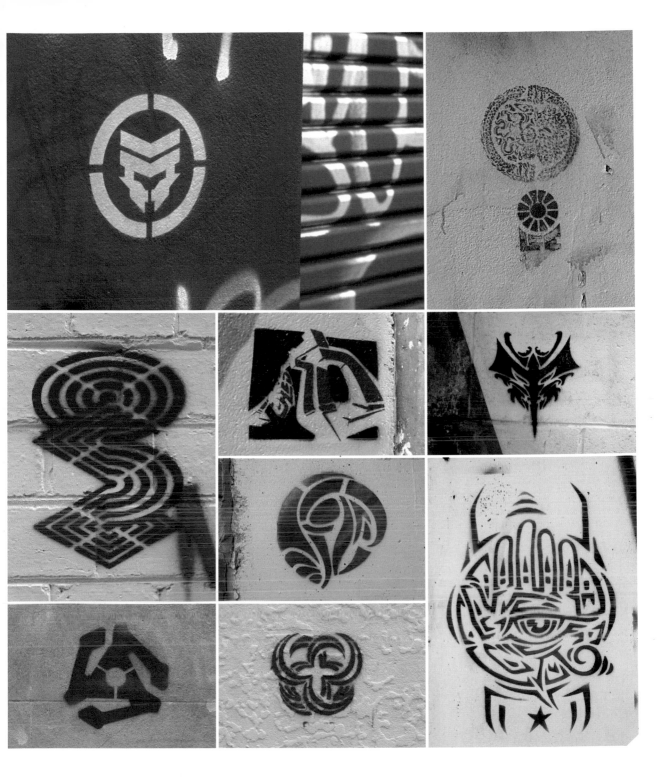

Opposite page, left to right from top: 'Shrine' by Strafe, photo: Mark Mansour / 'Train logo' by Puzle, photo: Carl Nyman / 'Orange logos', photo: Satta / 'M.U.F.F.', photo: Satta / 'Twisted Ink logo' by Numskull, photo: Satta / 'Cut Sum' by AXN, photo: Mark Mansour / 'Yellow symbol', photo: Jake Smallman / 'Box Cutters Union', photo: Mark Mansour / 'Red symbol', photo: Carl Nyman.

This page, left to right from top: 'OK101 army' by Kab101, photo: Jake Smallman / 'Gold symbols', photo: Mark Mansour / 'Red symbol', photo: Mark Mansour / 'logotype' by Presto, photo: Jake Smallman / 'Black symbol', photo: Mark Mansour / 'Secret Society' by Sync, photo: Carl Nyman / 'Urban Logic', photo: Satta / 'Red symbol', photo: Jake Smallman, photo: Jake Smallman / 'Hand' by Phibs, photo: Peter Casamento.

"I started just randomly vandalizing and burning things as a kid but I also really loved to draw in my sketchbook. I just never made the connection between the two at the time."

While studying art in Brazil, Prism first became aware of stencil graffiti: "There were many examples of socially and politically based stencils around. Little stencils for people to get their messages out there. It just inspired me to have a go at it myself and see what I could do with it."

He had also seen stencils by Banksy and Blek le Rat: "They had used their stencils in context with where they were doing it. I just enjoyed it so much that I wanted to try it myself. It was probably around 2000, 2001 that I cut my first stencil." This first stencil was of Australian Prime Minister John Howard, with devil horns.

Prism says his choice of topics varies from stencil to stencil: "It's whatever motivates me at the moment, whatever pisses me off or makes me feel something the most, whether it's a political message or a social thing or something completely different."

Since moving to Melbourne in 2001 he has witnessed the growth of the local scene: "Obviously, more people are aware of stencils because of the attention in media and fashion, it's been brought into focus. This in turn has gotten a lot of other people interested. Naturally, some of those have decided to try it themselves. The community has also become more organized. A lot of people are getting more experience in dealing with companies and doing work for commercial projects."

The website www.stencilrevolution.com has played a huge role in the spread of stencil graffiti both in Australia and throughout the world. Launched by Prism in October 2002, it boasts 15,000 registered members who have shared over 28,000 photos of their work.

The website contains artist interviews, discussion forums, show and event calendars and even has a tutorial section that provides lessons on both the fundamentals of stencil graffiti and advanced techniques. Discussions fostered by the website have given birth to *Overspray*, the only international magazine solely dedicated to stencils.

Prism speaks humbly about starting Stencil Revolution: "There wasn't anything like it on the internet. There were online communities for people that play computer games and there were online communities for all these other kinds of things but there wasn't any one place for sharing or discussing ideas about stencils and stencil graffiti. It was just a matter of seeing a gap that needed to be filled and then doing it."

More recently he has branched out into other areas like freehand graffiti, sculptural pieces, characters and paste-ups. Prism has also exhibited paintings in a number of shows. About stencils he says: "It's just another technique for expressing an idea." Where the idea gets expressed, however, matters and he does impose limits: "No religious places, no small businesses or homes. Anything else is fair game."

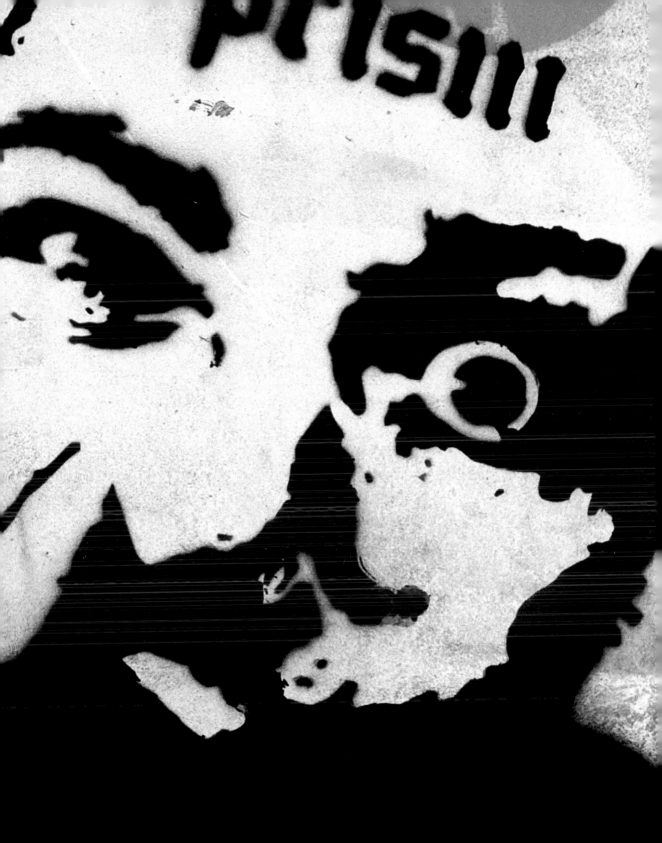

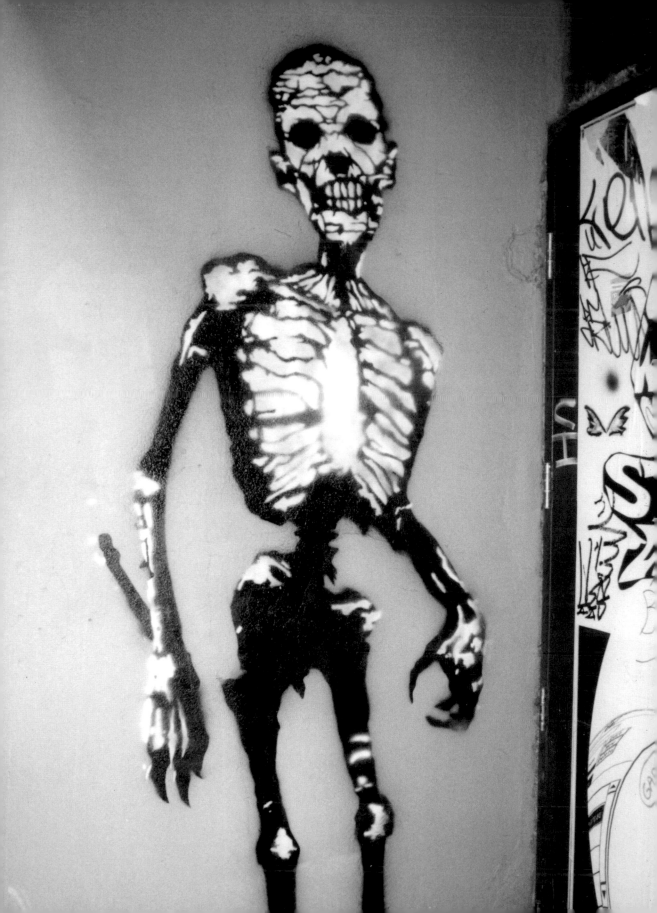

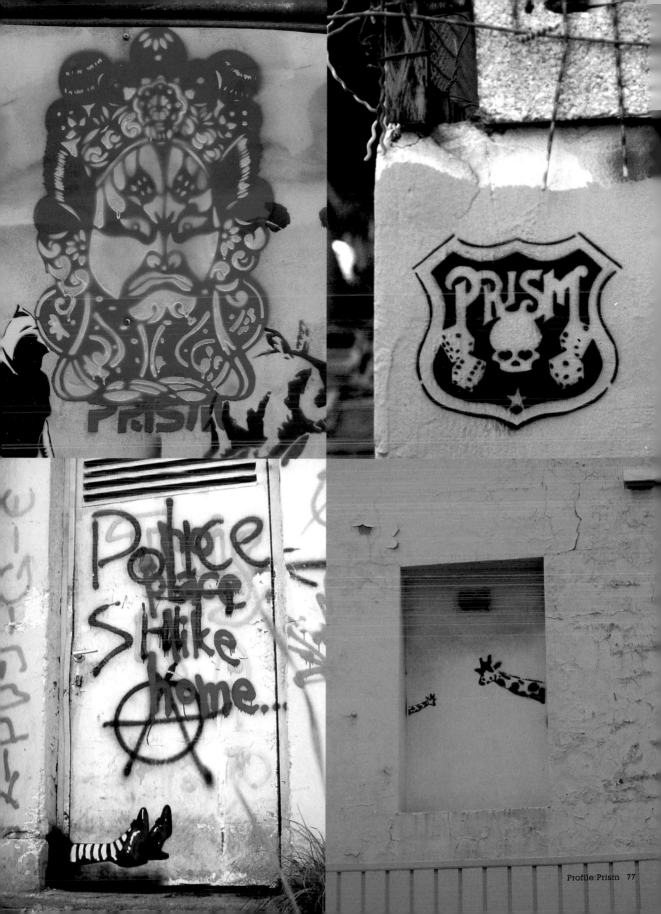

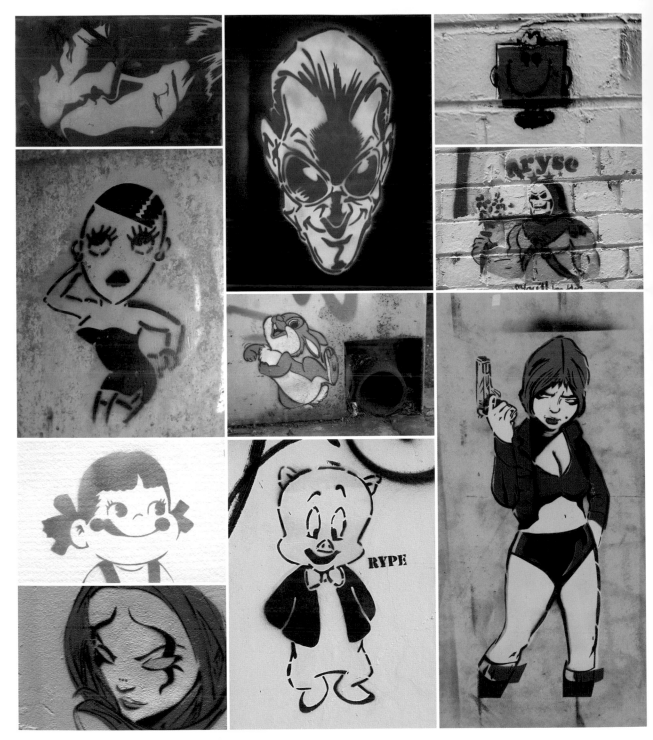

THEME:CARTOON/COMICS

Like the robots and mechs, on page 54, cartoon characters and comic book heroes are yet another reminder of childhood years. The clean lines and limited color palette of many comic book designs lend themselves perfectly to the stencil technique.

Usually not original in design, when turned into a stencil, these characters take on new meanings when sprayed onto the street, leaping off the printed page into real life.

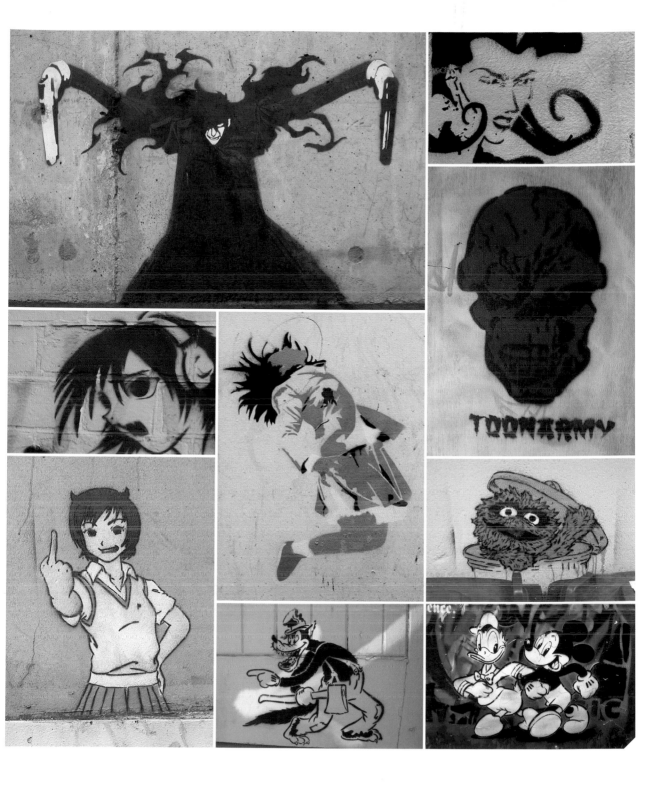

Opposite page, left to right from top: 'Ninja Scroll Kiss' by Optic, photo: Shyam Ganju / 'Orange face' by JF Fury, photo: Carl Nyman / 'Mr Strong', photo: Satta / 'Betty Boop', photo: Satta / 'Skeletor' by Aryse, photo: Mark Mansour / 'Thumper', photo: Mark Mansour / 'Gun girl', photo: Mark Mansour / 'Peko' by Bungle, photo: Jake Smallman / 'Porky Pig' by Rype, photo: Mark Mansour / 'Purple woman' by monkey, photo: Jake Smallman.

This page, left to right from top: 'Hellsing' by Bungle, photo: Jake Smallman / 'Manga girl', photo: Satta / 'Toon Army' by Cal, photo: Carl Nyman / 'Red manga girl', photo: Satta / 'Gunshot girl', photo: Mark Mansour / 'Devil girl', photo: Mark Mansour / 'Oscar the Grouch', photo: Mark Mansour / 'Big bad wolf' and 'Donald Duck and Mickey Mouse' by Civilian, photos: Mark Mansour.

'Cartoon face' by Optic, photo: Shyam Ganju.

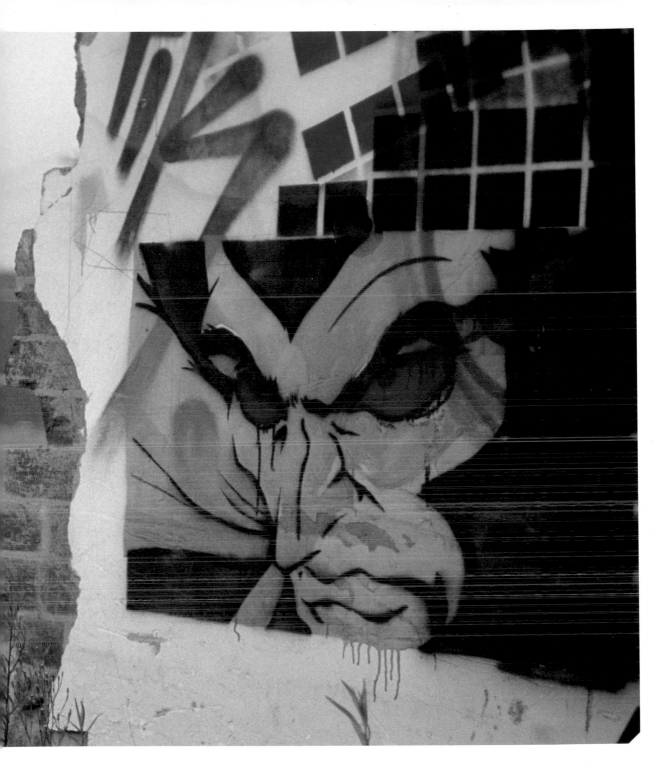

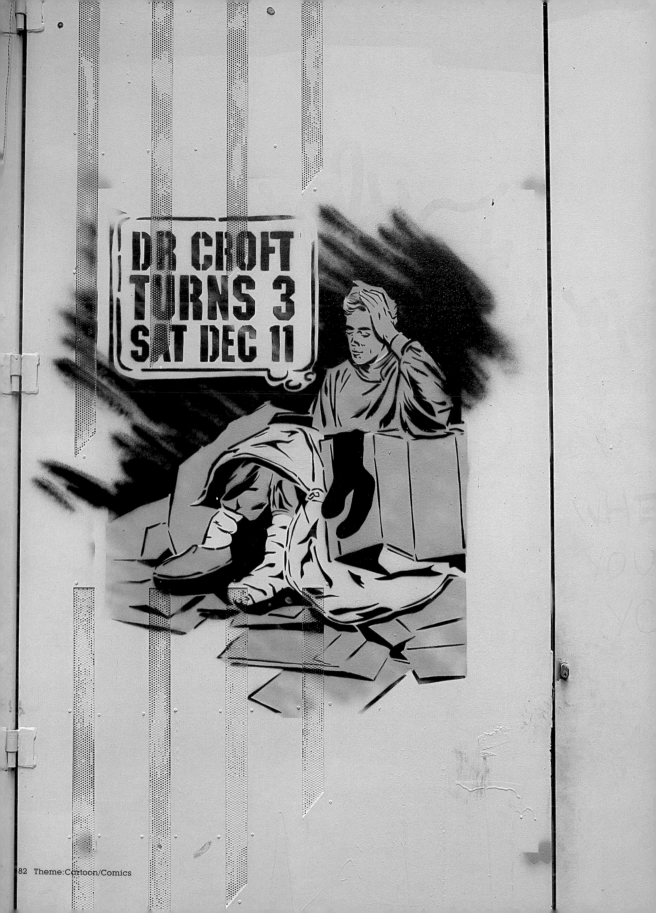

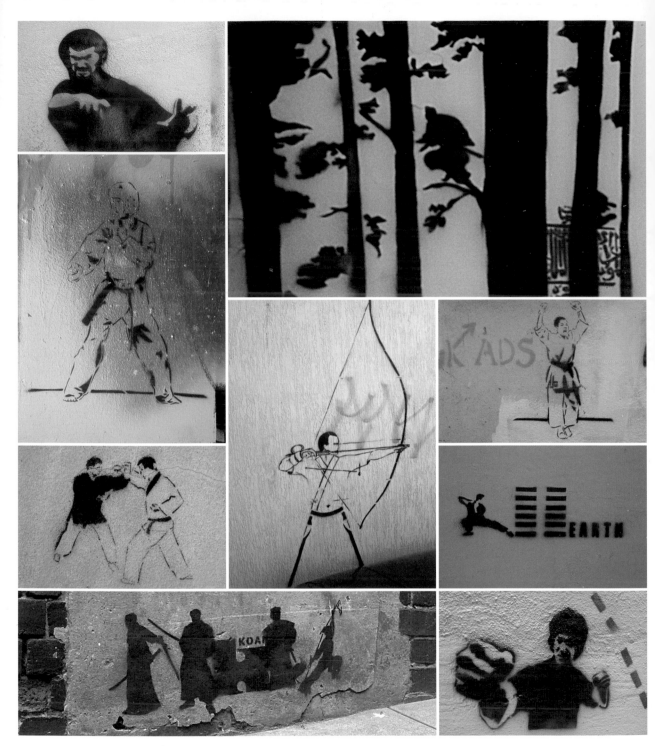

THEME:KUNG FU

Stencil graffiti artists are constantly battling for space amid advertising and the work of other street artists. There could be a correlation between stencil graffiti and martial artists both practicing an exact art, but it probably has more to do with the fact that a lot of young males like kung fu films. Just like in street art, there is action and sometimes violence, but always a code of honor.

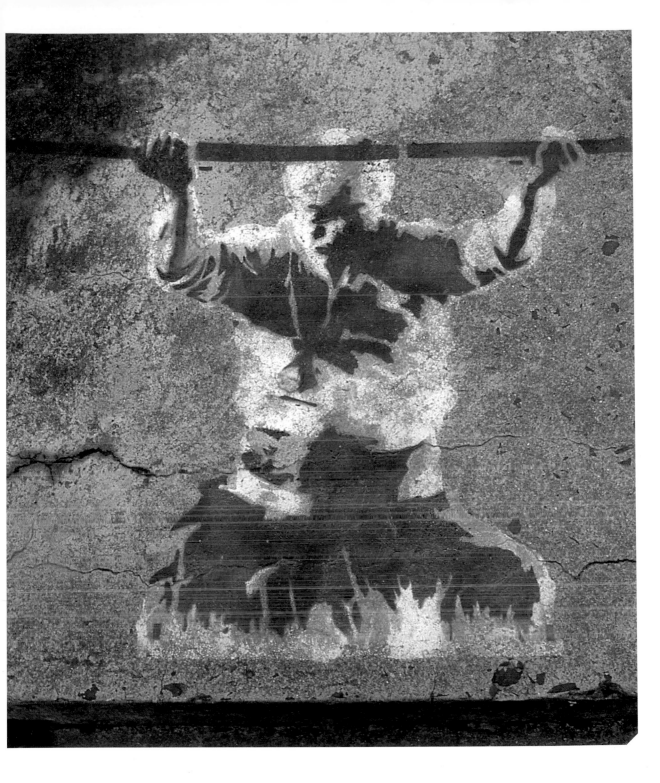

Opposite page, left to right from top: 'Afro fighter' by Monkey, photo: Mark Mansour / 'Ninja scroll' by Optic, photo: Shyam Ganju / 'Tae Kwan Do', photo: Carl Nyman / 'Archer', photo: Mark Mansour / 'Victor', photo: Satta / 'Karate', photo: Satta / 'Earth', photo: Satta / 'Koan ninjas' by Koan, photo: Jake Smallman / 'Bruce Lee', photo: Satta.

This page: 'Samurai' by Meggs, photo: Carl Nyman.

BANKSY:IN MELBOURNE

The world's most well-known stencil artist resides in London and goes by the name Banksy. Although Banksy has been a well-respected name in street art for many years, it's his art stunts that have brought him to the attention of the general public.

In May 2005, Banksy disguised himself as an elderly British tourist and successfully snuck his work into some of the most famous museums in New York City and London, placing it alongside the old masters and contemporary heavyweights. A year earlier he had done the same at the Louvre in Paris.

Other pranks include a full-scale copy of Rodin's "The Thinker" but with a traffic cone on its head and renamed "The Drinker." Years earlier, Banksy had climbed into the cages at the zoos in Bristol, England, and Barcelona, Spain, where he scrawled messages from the point of view of the animals: "I want out. This place is too cold. Keeper smells," "We're bored of fish, we wanna go home" and "Boring, boring, boring."

The core of Banksy's work, however, is stencil graffiti. Clever and thought-provoking, his stencils are found primarily in London but also in many other cities, from Copenhagen to Kingston, and of course, Melbourne.

In 2003, Banksy was invited to Sydney, Australia, to paint at the Semi-Permanent Design Conference. Before leaving the country he paid Melbourne a quick visit for some recreational bombing. With a bit of help from local guides, Banksy put up more stencils in less than a week than many others do in a year. Suddenly his signature rats were painted all over town, an invasion of rodents impossible not to notice.

The same as his dedication impressed the local scene, Banksy was impressed by the stencils he saw during his stay: "The walls of Melbourne are very noisy, but not in a shouty New York kind of way, more like the noise of a hundred drunk people talking amongst themselves. It makes everybody, whether they like it or not, feel more free. The city doesn't look like it's run by mean-spirited bureaucrats and the police. It looks like the city belongs to anyone who wants it. It feels like there's more opportunity."

His rampage on the city inspired many newcomers to cut their first stencil and during the weeks and months that followed, stencil graffiti exploded onto the streets of Melbourne.

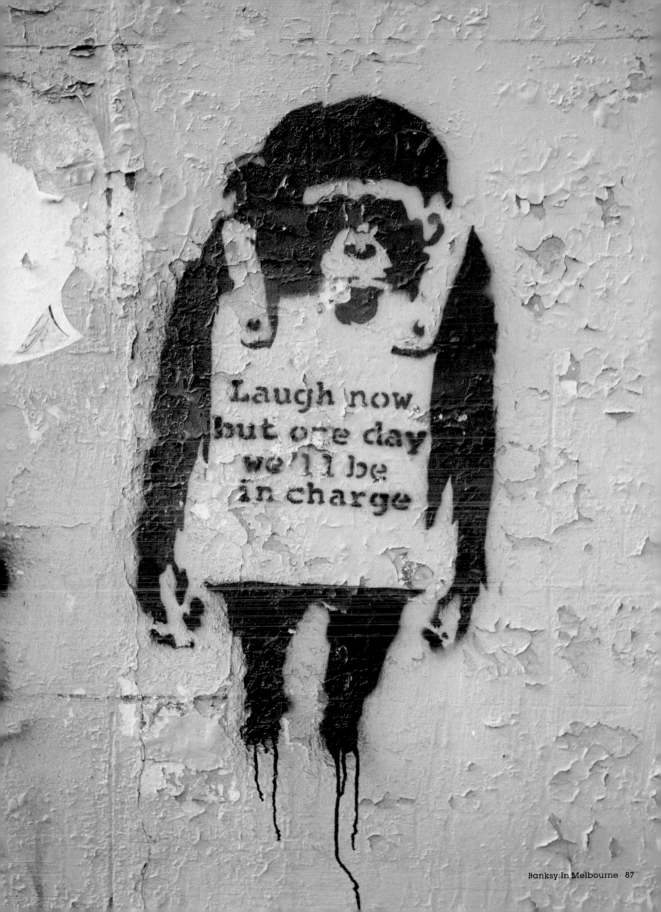

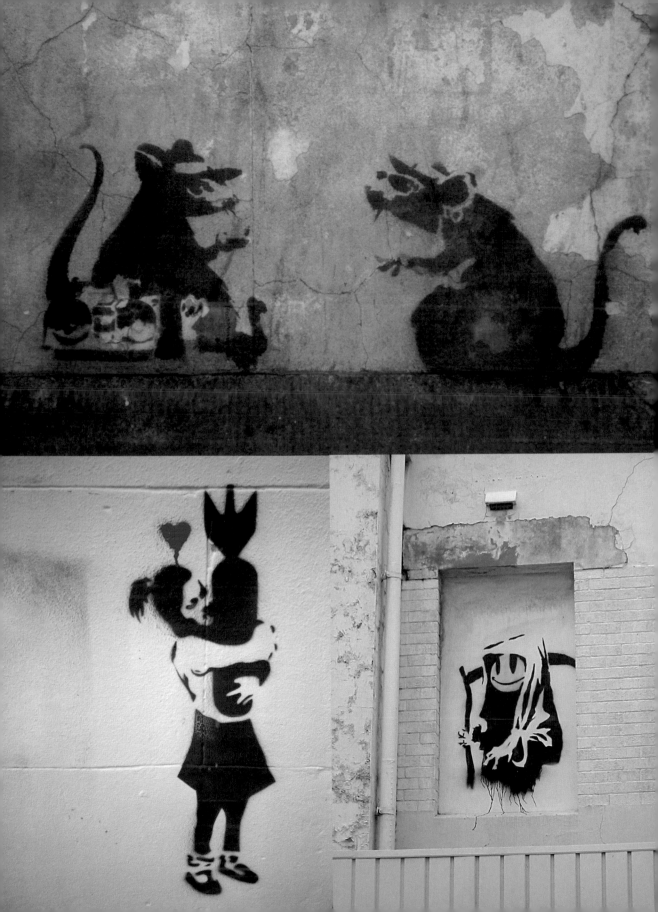

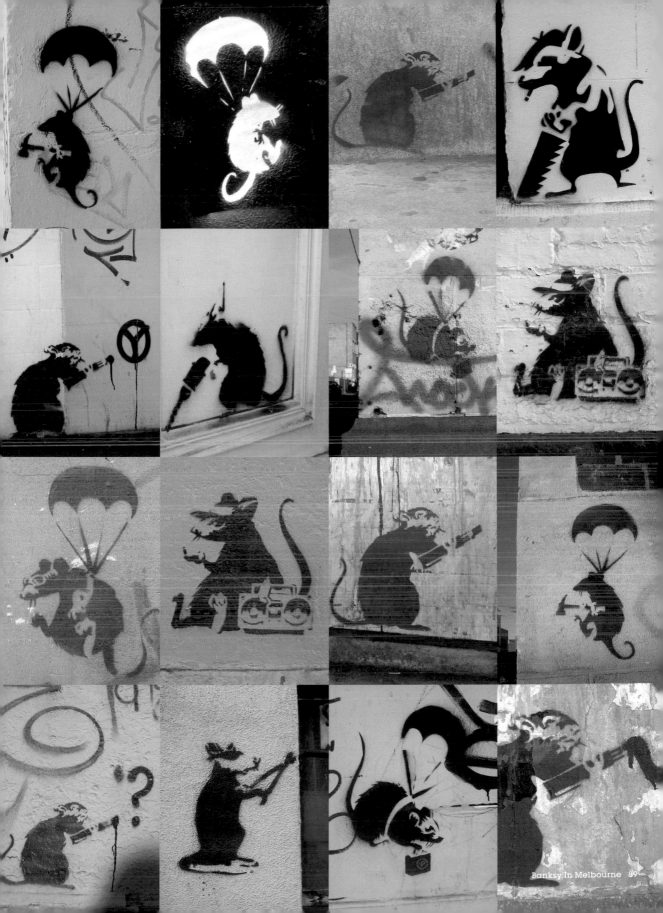

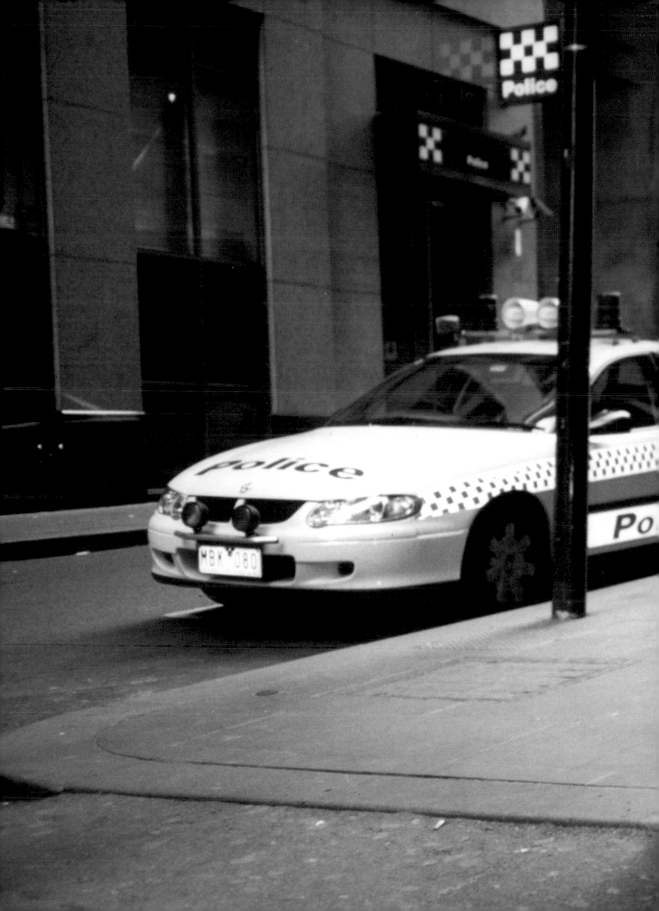

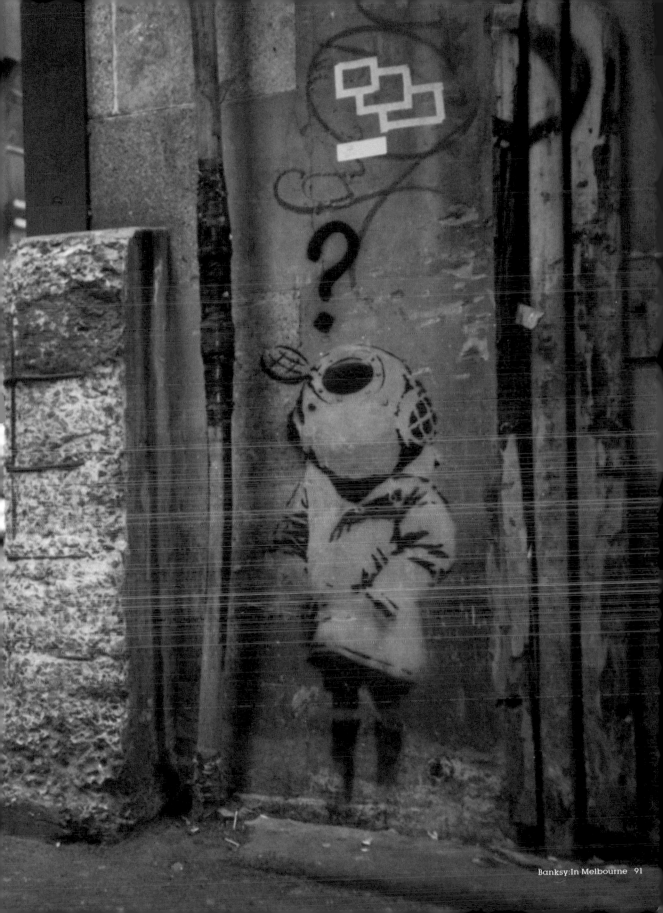

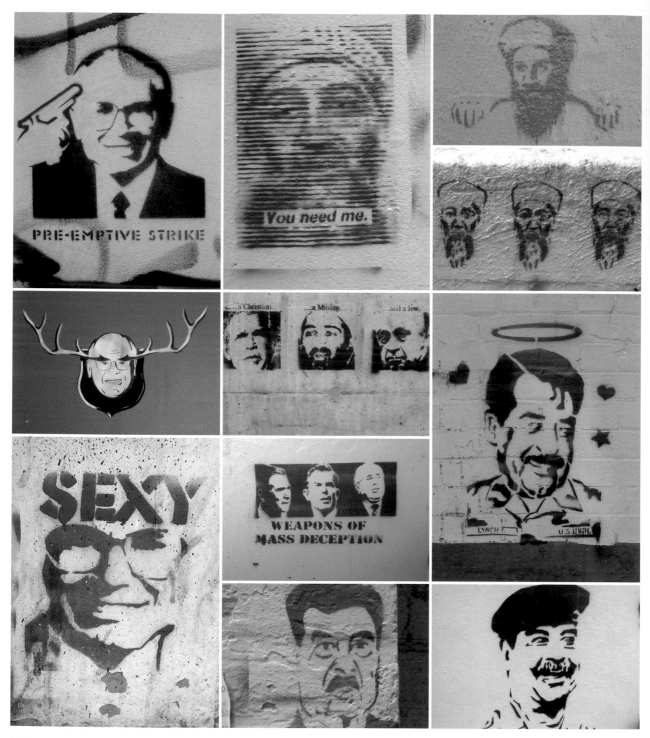

THEME:POLITICIANS

No politicians are safe from being mocked, especially when their actions do not receive the public's approval. George W. Bush has been a favorite target of satire since the day he took office. When he stepped in line with Bush, Australian Prime Minister John Howard put himself in the line of fire. Not a politician in the traditional sense, Osama Bin Laden's religious and political motivations have earned him a place among his enemies.

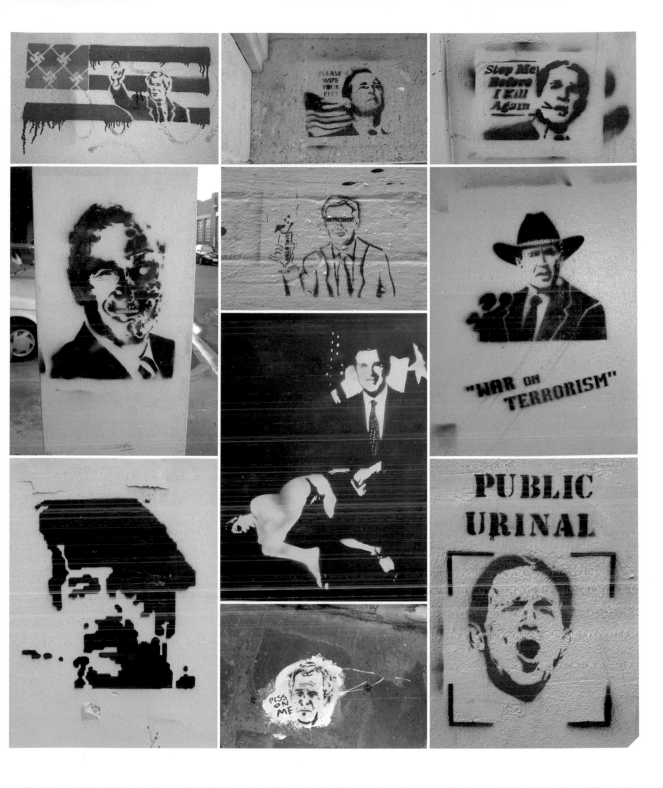

Opposite page, left to right from top: 'Pre-emptive Strike', photo: Satta / 'You need me' by Dlux, photo: Satta / 'Blue Osama', photo: Satta / 'Red Osama', photo: Satta / 'John Howard' by Bert, photo: Carl Nyman / 'a Christian, a Muslim and a Jew', photo: Satta / 'Angelic Osama', photo: Carl Nyman / 'Sexy' by Dominic Allen, photo: Peter Casamento / Weapons of Mass Deception, photo: Carl Nyman / 'Red Saddam', photo: Satta / 'Smiling Saddam' by Dlux, photo: Carl Nyman.

This page, left to right from top: 'Nazi America', photo: Jake Smallman / 'Please wipe your feet' by Azlan, photo: Satta / 'Stop me before I kill again', photo: Mark Mansour / 'Bushinator' by Dolk, photo: Jake Smallman / 'Molotov President', photo: Satta / 'War on Terrorism', photo: Carl Nyman / 'Fill 'er up' by Hazer, photo: Jake Smallman / 'Pixellated Saddam' by Dlux, photo: Satta / 'Piss on me', photo: Jake Smallman / 'Public Urinal' by Monty Catsin, photo: Satta.

Sync, or Syn as he also calls himself, first made his name in Adelaide where he used to put-up stickers anywhere and everywhere: "I started stenciling in 1996 because I wanted to mass produce stickers; stencils are durable and work perfectly for this."

While still in Adelaide Sync worked as a bike courier. Thanks to his occupation he knew every little side street and was able to spread his work across the city. "I had a studio there for about three years, around 1997 or 1998," he remembers. "And in all that time, all I did was stencil on stickers and then head out on my bike after work, putting-up, getting out in different areas of the city every night." It's a habit he's kept up since moving to Melbourne.

Despite starting with stencils earlier than many, it wasn't until 2003 that Sync started making multi-layered stencils: "It's weird that I didn't start earlier. It's not that it's hard or anything but I just never thought of it and no one ever showed me how to do it, so I never really knew."

He often uses images from horror movies, suggestions of death and suffering, people in panic screaming and scared. The images are confronting and violent. His reason for the gruesome imagery: "I like that stuff." Then he goes on to explain, with a big smile smeared across his face, how he has actually passed out from pure fear while watching horror films: "I have a very lively imagination."

Sheer fear is not the only motivating factor behind these images: "I don't do anything political, like a president's face with a bullet hole in it. Instead I'll do a screaming face, which symbolizes the same kind of view because, you know, it's chaos in the world. It's just a different way to project that same kind of feeling."

In contrast to these images of horror and suffering Sync also uses imagery from old school hip-hop: "I do all these stencils of B-boys, and it's just because I love hip-hop. I like all that 1980s shit. I was a kid in the 80s and I think a lot of people can relate to it as well."

"I just draw and paint, whatever. Stencils so often work with the environment they're placed in. Mass production of one image can convey different messages to different people, communicating on many levels with the population. There is such a cross-section of people that appreciate stencils, people see, talk about and photograph them. The stencil generates its own audience, they become urban legends."

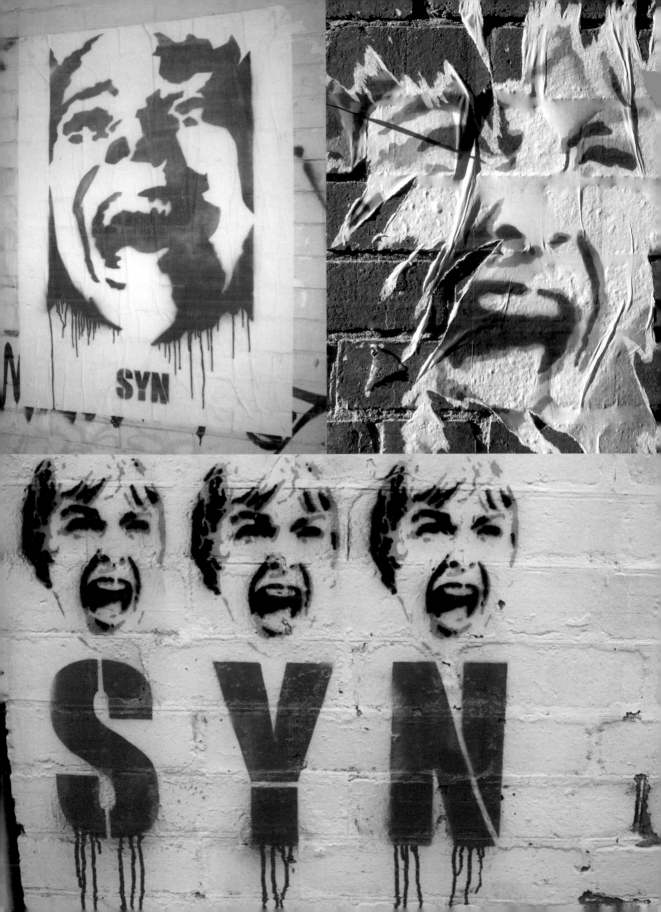

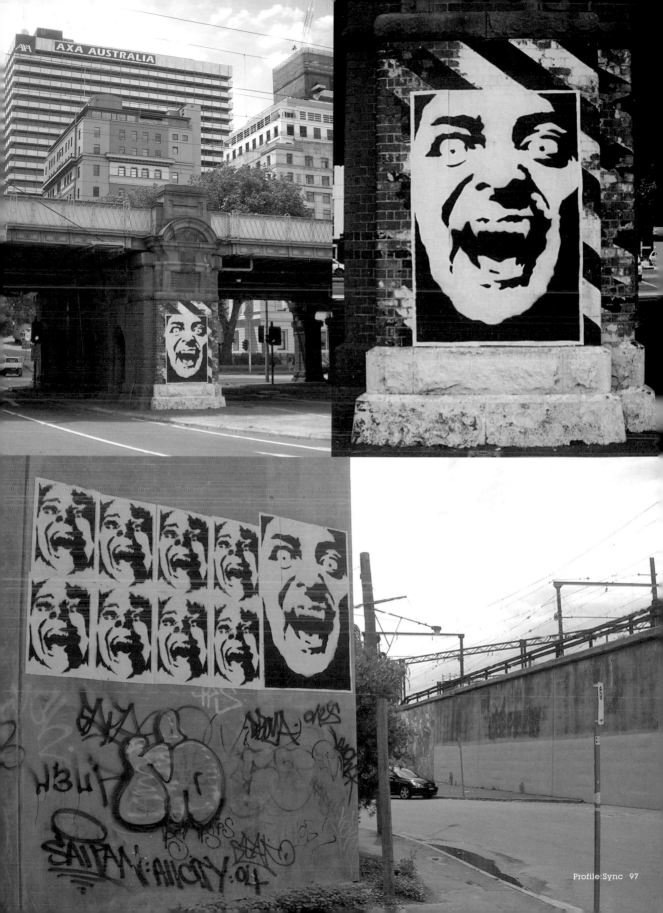

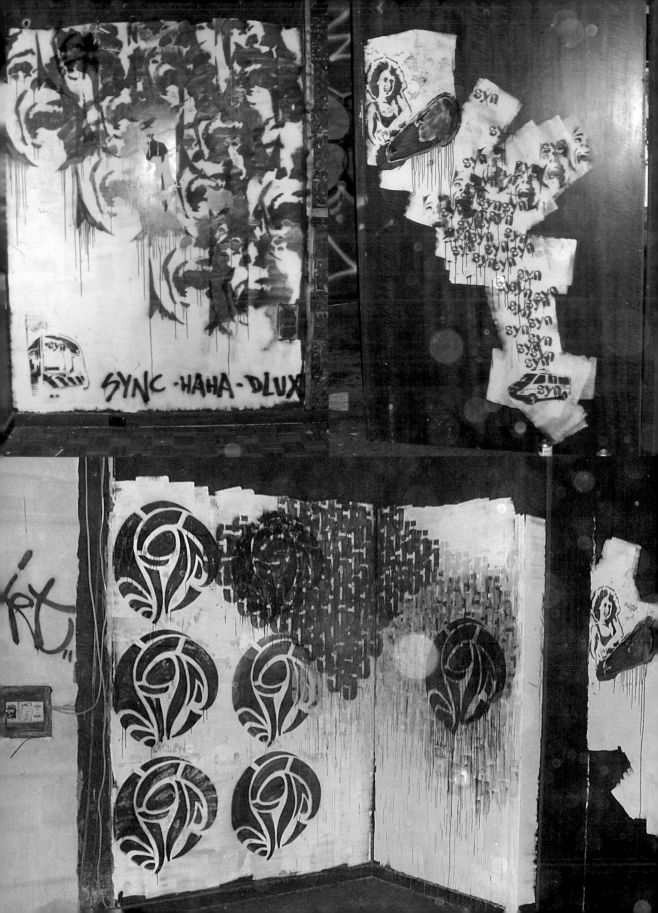

SYNC ·HAHA· DLUX

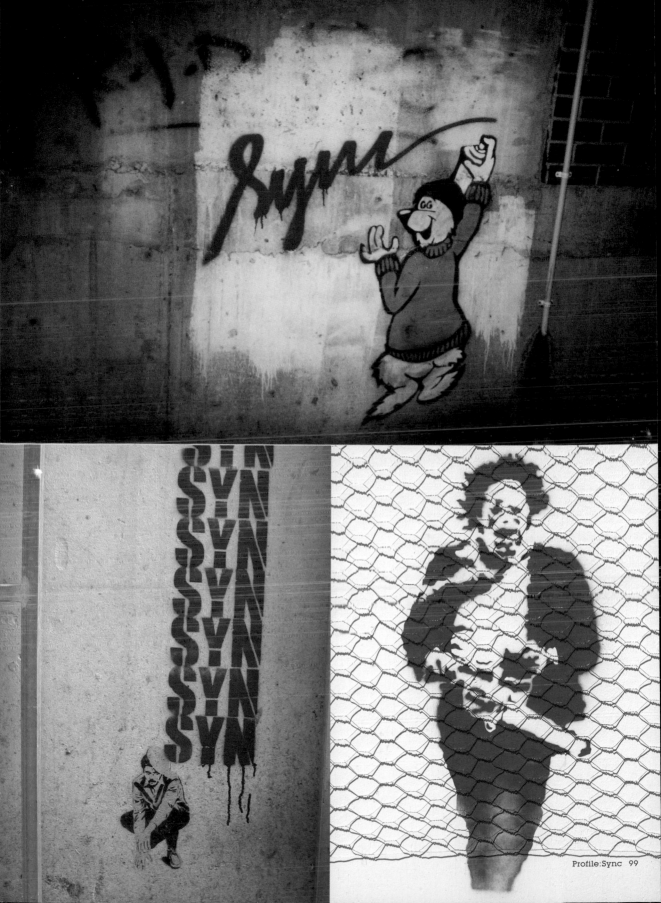

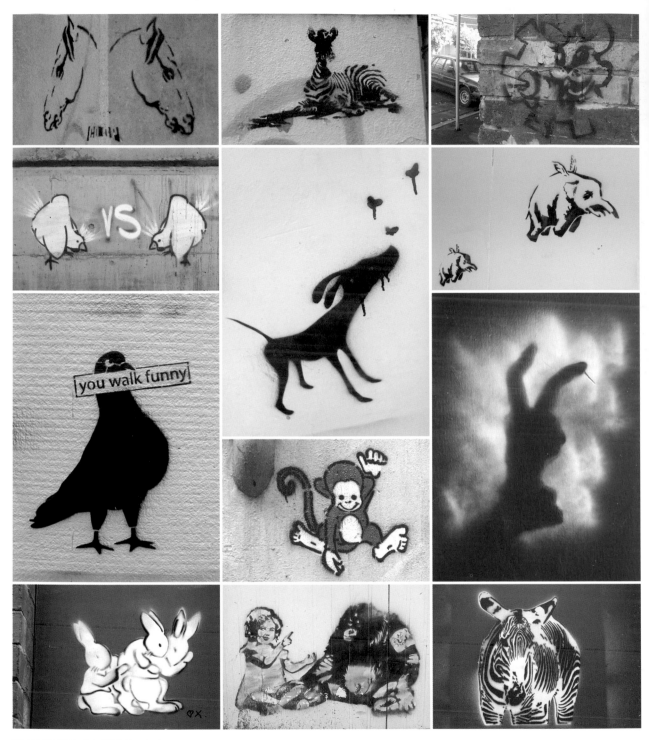

THEME:ANIMALS

Melbourne's streets are overrun by animals, and it's more than just rats and pigeons. From domestic pets to cute monkeys, anarchist bunnies and even full-size elephants, hordes of animals decorate the city's walls, making everyday a trip to the zoo.

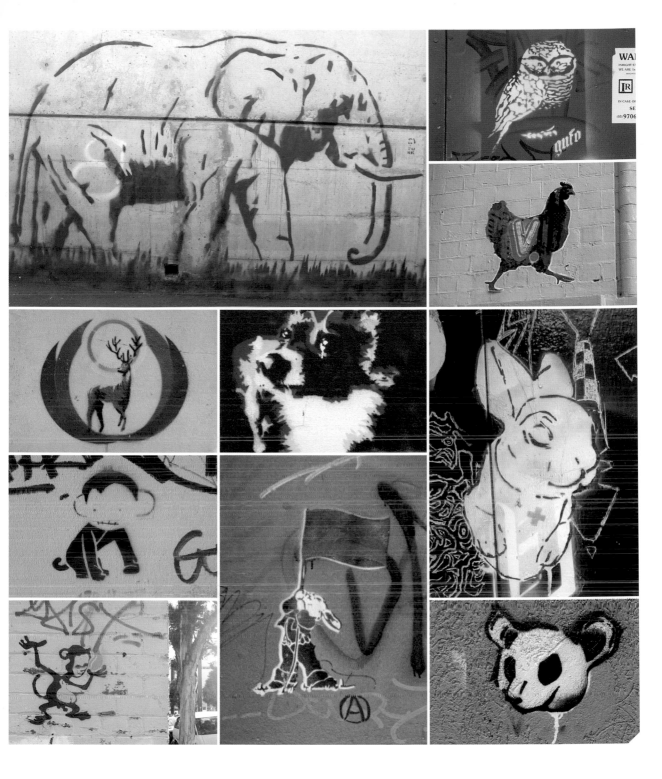

Opposite page, left to right from top: 'Horse' by Co-op, photo: Carl Nyman / 'Zebra' by Plush, photo: Satta / 'Raygun Rabbit', photo: Mark Mansour / 'Chicken Vs Chicken' by Monkey, photo: Satta / 'Dog', photo: Peter Casamento / 'Flying elephants' by Co-op, photo: Jake Smallman / 'You walk funny' by Bert, photo: Jake Smallman / 'Monkey', photo: Mark Mansour / 'Rabbit', photo: Mark Mansour / 'Three rabbits' by Xero, photo: Mark Mansour / 'Shirley Temple with gorilla' by Sevna, photo: Mark Mansour / 'Zebra', photo: Jake Smallman.

This page, left to right from top: 'Life size elephant' by Tusk, photo: Jake Smallman / 'Owl' by Gufo, Photo: Mark Mansour / 'Chicken' by Victim, photo: Satta / 'Deer' by Rone, photo: Jake Smallman / 'Dog', photo: Mark Mansour / 'Rabbit' by Co-op, photo: Co-op, 'Chimp', photo: Carl Nyman / 'Anarchist rabbit' by Civilian, photo: Civilian / 'Monkey', photo: Jake Smallman / 'Panda', photo: Peter Casamento.

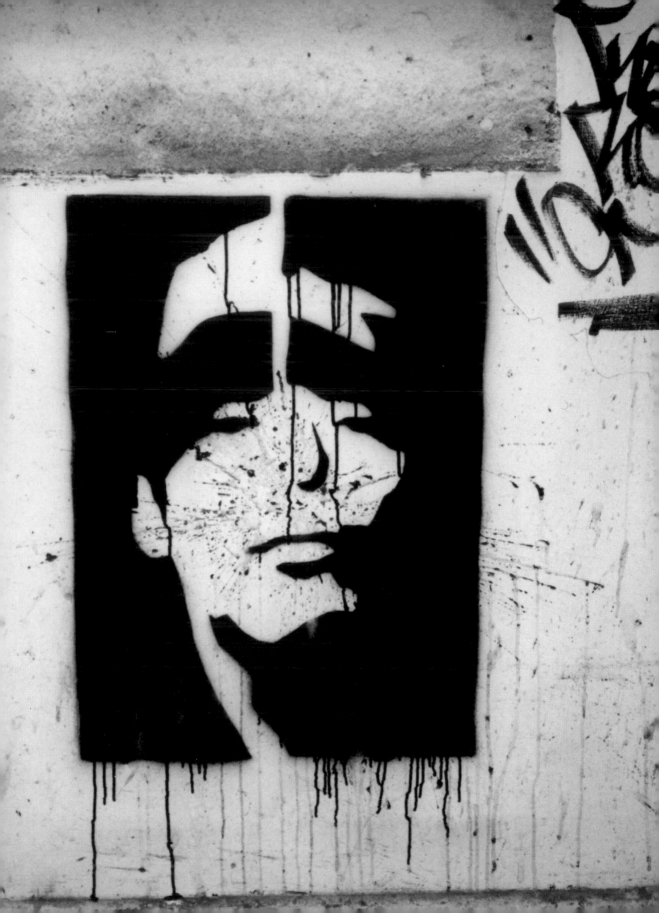

PROFILE:OPTIC

The suburbs of Carlton, Northcote, Collingwood and Fitzroy are all places Optic claims as his favorite hunting grounds. Moving through these areas you'll encounter his art quite frequently. The cold stare of rappers, soldiers and images from the film *Ghost Dog* dominate the areas. "I haven't been doing the city much lately because everything seems to get buffed quite quickly," he says. "I'll go down there occasionally, just to have a look and maybe if it feels right I'll put something up."

"I think it's fucking cool that Melbourne has arguably the hottest stencil scene in the world right now. I'm not really sure why there are so many people doing it; maybe because stenciling is like a virus infecting everyone who comes in contact with it." If this is true, Optic has certainly caught the bug. Despite having been chased by the police on a number of occasions and getting busted for stickering, he keeps getting up on the street. "I think the risk of getting caught is definitely a thrill. It keeps things interesting," he says with a grin.

Optic started stenciling in 2001. In the beginning he remembers, "I just did a few stencils here and there, did posters for my walls and just destroyed the furniture and the backyard. By 2003 I had started doing it more seriously, going out on missions, bombing and stuff."

"I enjoy putting work up in public places as a way of exhibiting my work. I like being able to work at home, to create the stencil and then be able to quickly and easily put-up a strong image on the street."

"Sometimes I do stuff off the street, on boards and shit, but I don't spend heaps of time doing it. For me it feels very different when I am working in my studio on a painting." Optic has had work in several shows and has also exhibited photography of street art in the past. He aims to offer viewers a different experience than what they get from encountering stencils on the street.

"In a way I'm kind of opposed to having art shows with stencils, I'd rather do something different. I think putting work in a gallery has to be carefully considered and that there should be some separation between street work and gallery work. Personally, I feel obligated to do something different from what I'm putting-up on the streets. I have issues with people having a show that's specifically what they've done on the streets, without any attempt to take it to the next level."

When talking about the future Optic wants to broaden his field of work: "I plan on doing more in galleries, not just street art style work. I want to do multimedia installations, make more short films and stuff like that."

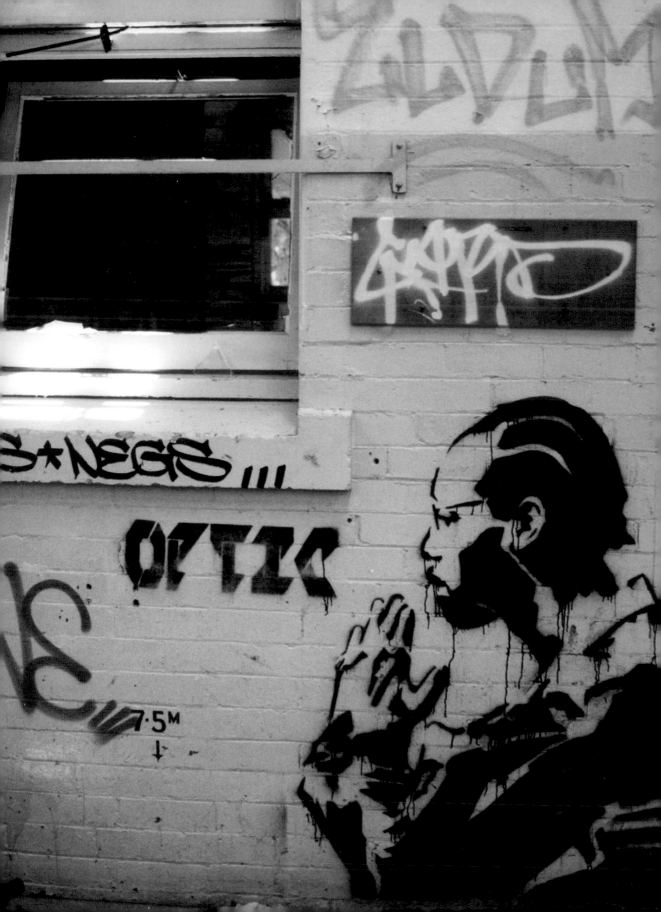

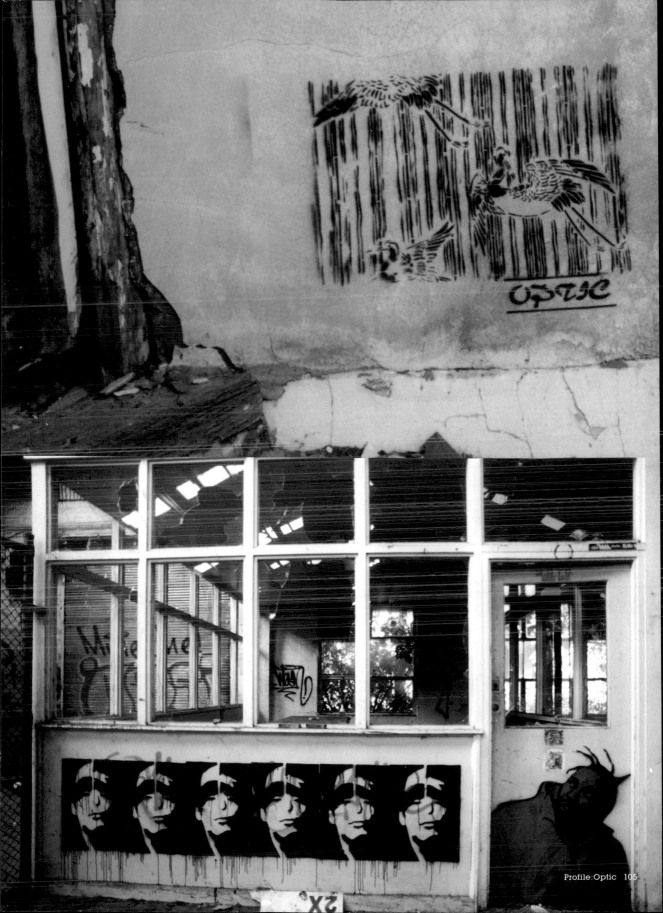

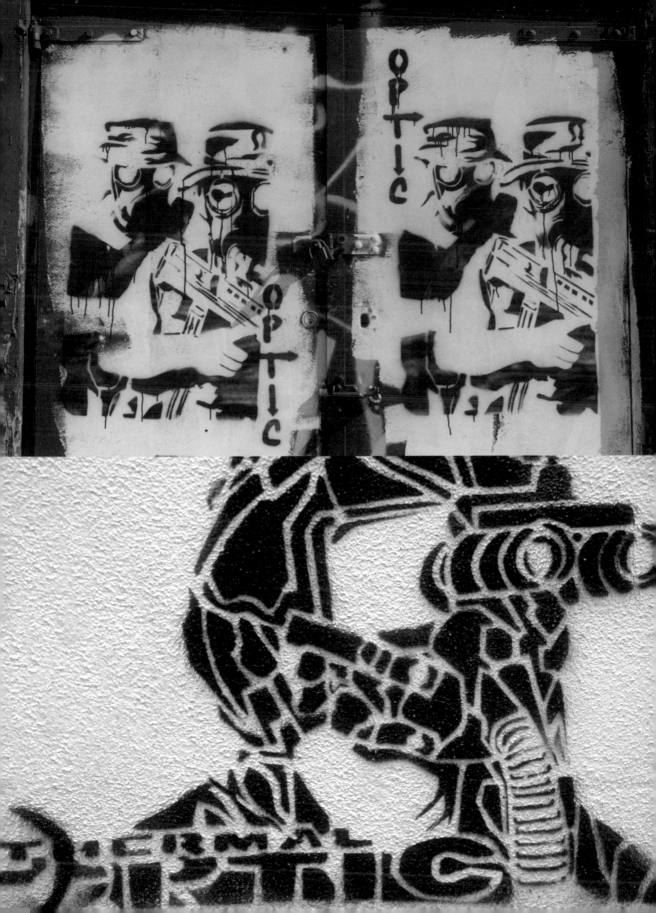

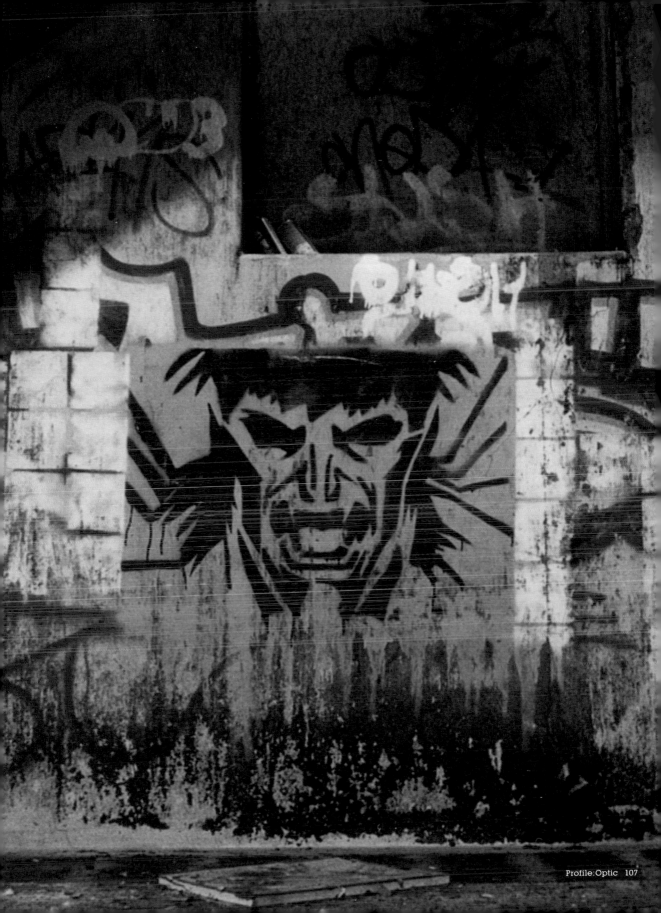

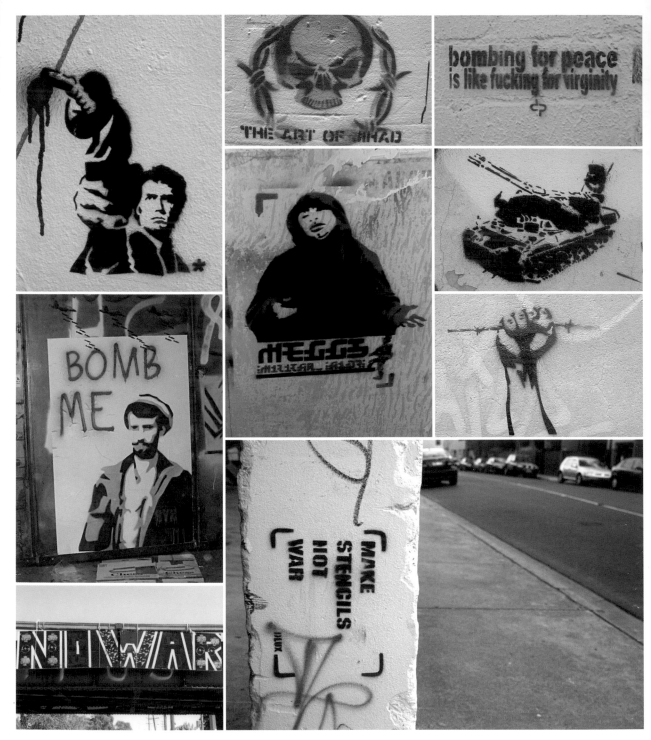

THEME:WAR

The American-led invasions of Afghanistan and Iraq have had global results. Anti-war stencils appeared as soon as troops were deployed. Often using clever designs and turns of phrase, they are reminders that the will of our leaders does not always match the will of the people they are supposed to lead.

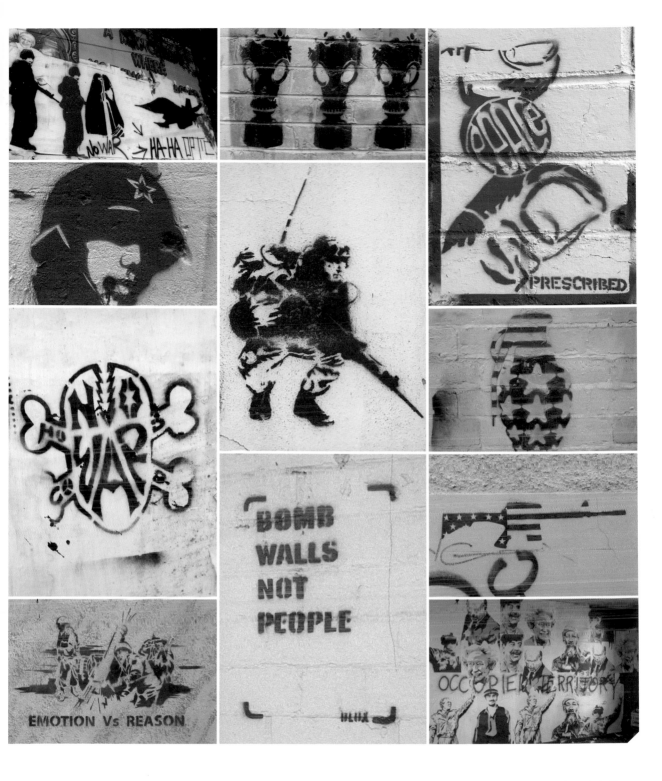

Opposite page, left to right from top: 'Clint Eastwood' by Meggs, photo: Mark Mansour / 'The art of jihad' by Wallad, photo: Jake Smallman / 'Bombing for peace' by DP, photo: Satta / 'Military Aid?' by Meggs, photo: Jake Smallman / 'Tank', photo: Satta / 'Bomb me' by Dlux, photo: Satta / 'Barbedwire in fist' by Satta, photo: Mark Mansour / 'No war' by Optic, photo: Shyam Ganju / 'Make stencils, not war' by Dlux, photo: Jake Smallman.

This page, left to right from top: 'No war billboard' by Ha-Ha and Optic, photo: Shyam Ganju / 'Gas masks', photo: Jake Smallman / 'Peace - prescribed', photo: Peter Casamento / 'Wounded soldier' by Monkey, photo: Jake Smallman / 'Signalman' by Plush, photo: Peter Casamento / 'No war, Howard, Coward', photo: Peter Casamento / 'US grenade', photo: Jake Smallman / 'Bomb walls not people' by Dlux, photo: James Dodd / 'US machine gun' by Dolk, photo: Mark Mansour / 'Emotion vs. reason', photo: Satta / 'Occupied territory' by Dlux, photo: Carl Nyman.

'No blood for oil' by Optic, photo: Shyam Ganju.

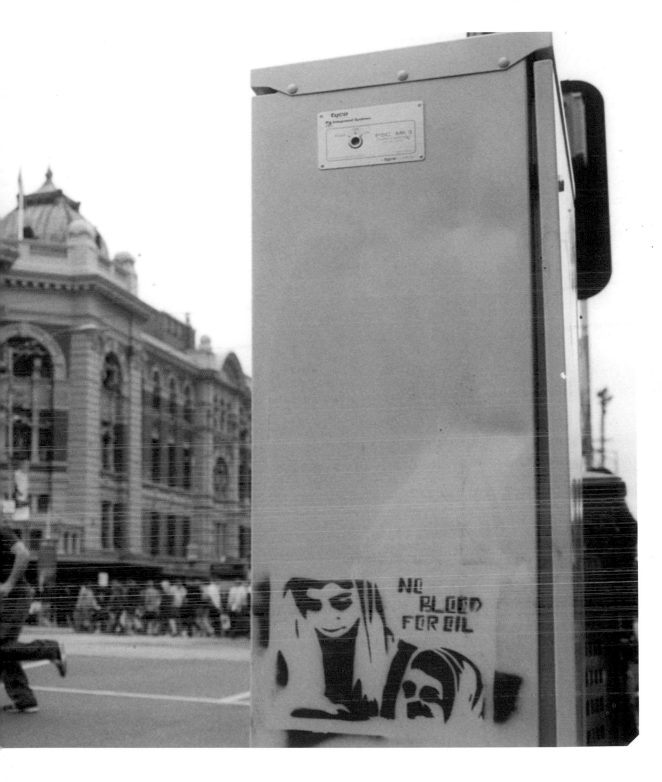

Coming from a background of traditional graffiti, tagging and piecing has always been Phibs's forte. He has been active on the streets for more than 15 years. "I've always enjoyed experimenting with different ideas and materials," he recalls. "I have been mucking around with stencils for the last 8 to 10 years, but it was only on cards, clothes and artwork, which were usually given to friends or family. It was the move from Sydney to Melbourne that inspired me to use it as a way to get-up in the urban environment. I have only been bombing my stencils on and off for the last three years, so I don't see myself as the most dedicated stenciler, but my interest in it is constantly growing due to the huge street art scene here in Melbourne, be it paste-ups, stickers, tagging or stencils."

His work is always quite detailed and intricate: "I wanted to come up with very complex designs which could be sprayed up in seconds, and as many times as I wanted."

"I get a lot of my inspiration from the art and mythology of other cultures, especially Aztec and Mayan, and I've been able to incorporate some of that into my own artwork, which gives it a distinctive style. A lot of my work is subconscious, and the meaning might not become clear until it is finished. I like the fact that it might mean something different for each individual. Like graff, there is a select audience I reach with my stencils, but for me, it makes it all the more worthwhile when people who aren't normally interested in the scene take it in and appreciate it and sometimes even see a message behind it."

Part of the street art scene longer than many people and having witnessed its birth as an underground movement that has developed into a trend Phibs doesn't think stencil graffiti necessarily needs to be limited to the streets: "Although I do think that's where it draws most of its strength, gallery exhibitions, clothing and so on are a way for new audiences to be reached. However, stenciling's strength comes from the fact that there's art on the street that can't be bought or sold. Street art still maintains a rawness and edge that can't be replicated in a gallery space."

In the urban environment signs, logos and advertisements assault urban denizens from every angle. The same as the city's landscape affronts people with countless brand identities it only makes sense that street artists want to establish their own creative identities. This is how Phibs sees it: "That's partly why I choose to paint or stencil in the inner city. I like to have my own message up there along with all the others."

There seems to be even more relevance to this approach as the distinction between company created advertising and individual art blurs: "There are a lot of companies using stencils, and even graffiti, as advertising, and I guess that's because they're cashing in on a demographic that sees this art form as edgy and controversial. The irony is that the use of stenciling and graff in advertising is seen as just that, advertising, whereas the same art form by an individual might be portrayed or interpreted as vandalism."

"For me, it's art for art's sake. With art, it's about using my hands, and although I don't have a problem with other people using computers and machines, it's not something I'm interested in doing. In some ways, I think if I used a computer to help generate, or a machine to help cut my stencils, my work would lose some of its rawness, and for me, part of the challenge is to attain that detail and accuracy using my hands. I guess my hand-eye is a representation of that. The eye takes in the information, and the hand takes that information and produces something from it. To me, that image represents creation, and is iconic in some ways of myself."

"Artwork is like a religion to me. As long as I can practice what I think I'm here to do, I feel like I have a purpose, that I have meaning."

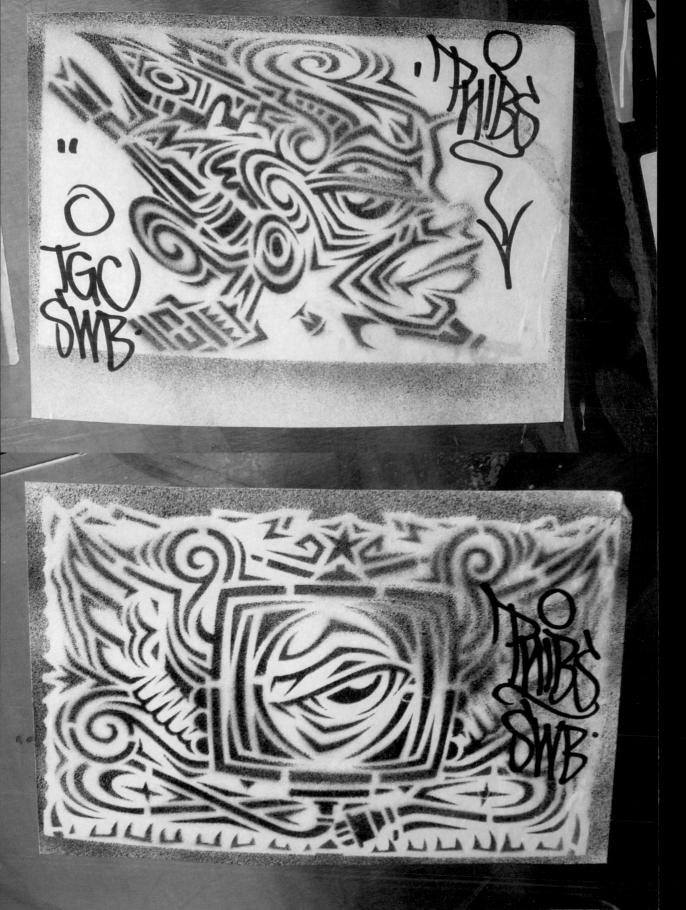

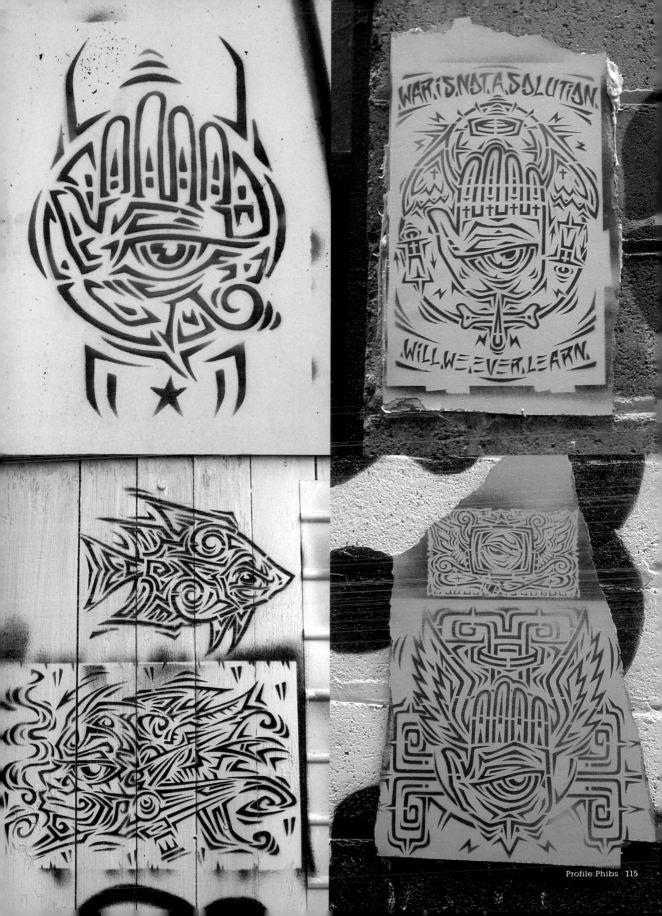

WAR.IS.NOT.A.SOLUTION.

WILL.WE.EVER.LEARN.

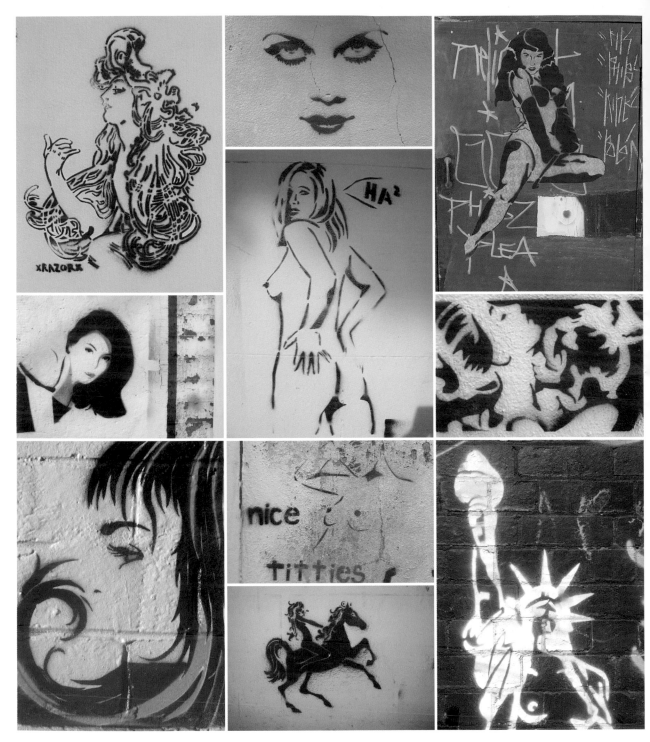

THEME: SEXY LADIES

Girls, girls, girls. A celebration of the female form or merely a sign of sexual frustration, women's bodies have been an obsession for artists since the beginning of time. In the world of stencil graffiti this is as obvious as ever. From Lady Godiva to Jennifer Garner, sexy ladies adorn many walls eliciting smiles from passersby.

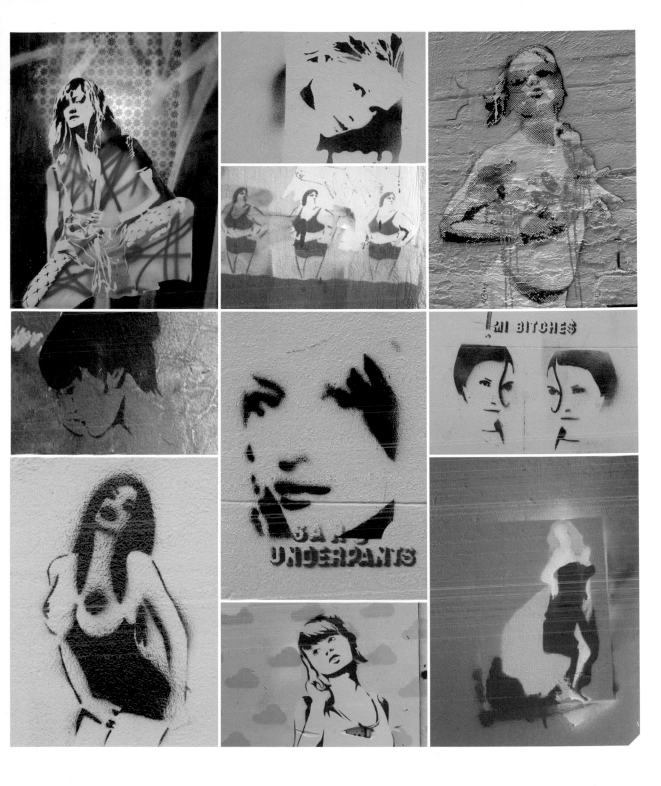

Opposite page, left to right from top: 'Art nouveau lady' by Razor, photo: Mark Mansour / 'Red lipstick', photo: Jake Smallman / 'Reclining lady', photo: Mark Mansour / 'Phyliss' by Bungle, photo: Jake Smallman / 'Naked lady' by Ha-Ha, photo: Mark Mansour / 'Ladies kissing', photo: Jake Smallman / 'Blue haired lady', photo: Jake Smallman / 'Nice titties', photo: Satta / 'Statue of liberty' by Meem, photo: Annette Willis / 'Lady Godiva', photo Jake Smallman.

This page, left to right from top: 'Lucy' by Rone, photo: Rone / 'Alias', photo: Jake Smallman / 'Halftone dot lady' by Sugarushgirl, photo: Satta / 'Three fat ladies', photo: Mark Mansour / 'Pink face', photo: Satta / 'Sans underpants', photo: Mark Mansour / 'Mi bitches', photo: Satta / 'Topless woman', photo: Peter Casamento / 'Listening lady' by Monkey, photo: Mark Mansour / 'Flamenco lady', photo: Jake Smallman.

Mention stencil graffiti in Melbourne and the first name that usually comes up is Ha-Ha. The term prolific is an understatement. He is simply everywhere. What some may see as a vandalizing rampage with little regard for public or private property, Ha-Ha sees as a good night out. "The risk of getting caught is the ultimate thrill; it's better then sex," he claims. "I love stenciling down main streets. I get turned on when I walk down say, Smith Street during the day and see my, or other people's, stencils there."

"I've been doing stencils since sometime in 2000 and started because all my friends were involved in some form of street art or street vandalizing and graffiti. I use stencils because an image says more than say a tag or graff. Stencils make a statement that fucks with people's heads."

Not many people think of vandals as having a strong work ethic, but that's exactly how Ha-Ha manages to make his work so visible in and on the city. "I used to work as a garbo for the cities of Whitehorse, Moreland and Glen Eira and took hundreds of stickers to work each week and stuck them up all over," he explains. "Now I mainly stencil in and around the city, Fitzroy, Collingwood, Brunswick, Richmond, areas all close to home."

Not only does Ha-Ha put-up stencils in lots of places, but he also does many at a time. His use of repetition is one of the most striking things about his art. Going out bombing with him is an overwhelming experience. In the time that most others have finished their first stencil, Ha-Ha has done three and is already working on a fourth. Some people in the stenciling community don't see the point in putting-up everywhere and consider a lot of Ha-Ha's work as nothing more than stencil tagging. When asked about why he does it he simply replies, "One stencil is beautiful, four stencils are four times as beautiful." Who can argue with that?

The repetition could also be seen as a nod to pop art, a title his work has received in the press on more than one occasion which is not surprising since much of Ha-Ha's subject matter is taken from popular culture: "When Osama Bin Laden and terrorism was big, I went out and did stencils relating to that. When Star Wars came out, I went out stenciling Storm Troopers and Darth Vader around town." His favorite and most reoccurring theme, however, is robots: "I love robots and try to do as many robot stencils as possible. I really want to be a robot." If there is any sarcasm in that comment he hides it well.

"I get heaps of young kids coming up to me saying that I'm the reason they started stenciling on the streets, so whenever I cut a new stencil for the streets, I'm giving back to all those young kids who came up to me shook my hand and said thanks. My stencils are for them. Psalm inspired me, I inspired someone else and the list goes on."

Ha-Ha is a professional artist and gallery curator, with several gallery shows under his belt: "I used to paint some kind of warped cubic, pop thing but now I just do stencils. I think exhibiting is good; if you have a talent you should make the most of it. I'm always broke and strapped for cash, so if I can sell work I can pay my bills and buy more spray paint. But I still prefer illegal underground exhibits such as the 'Empty Shows'."

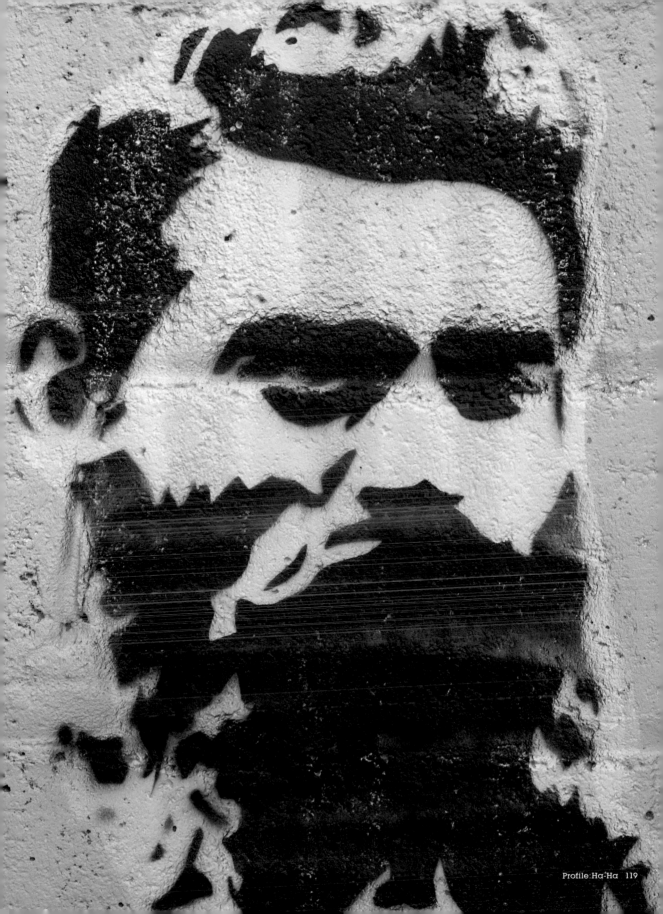

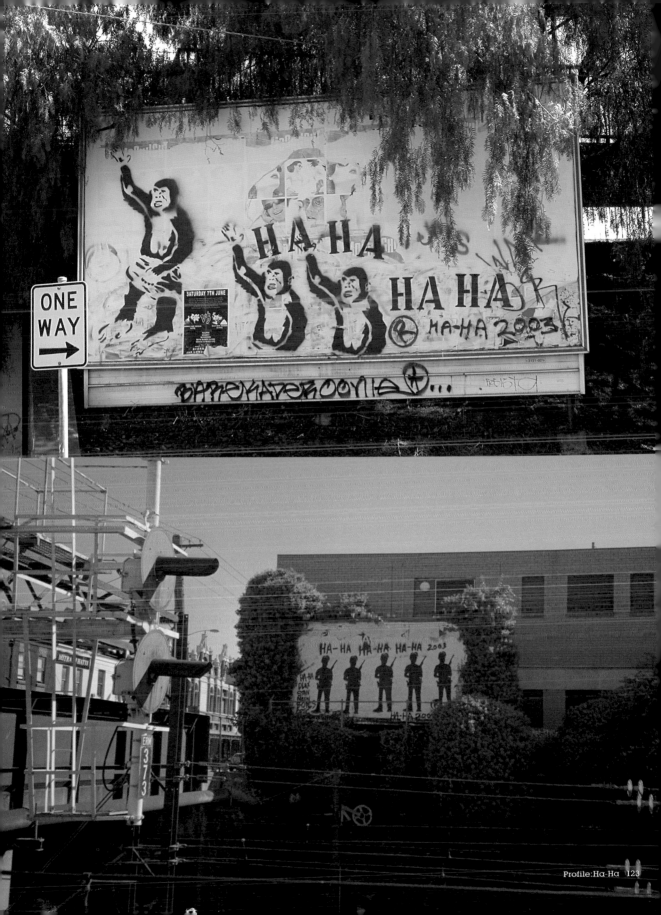

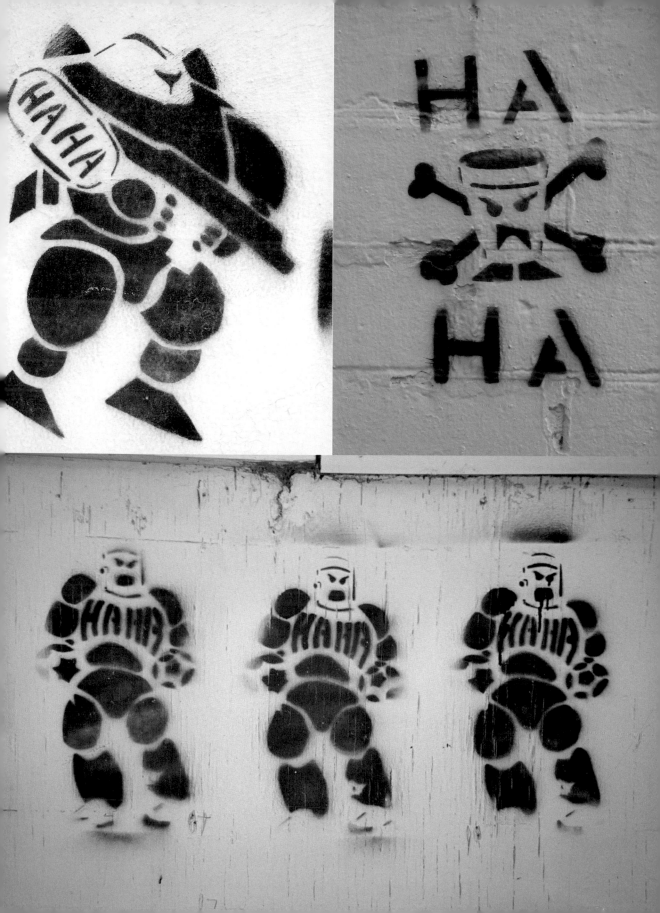

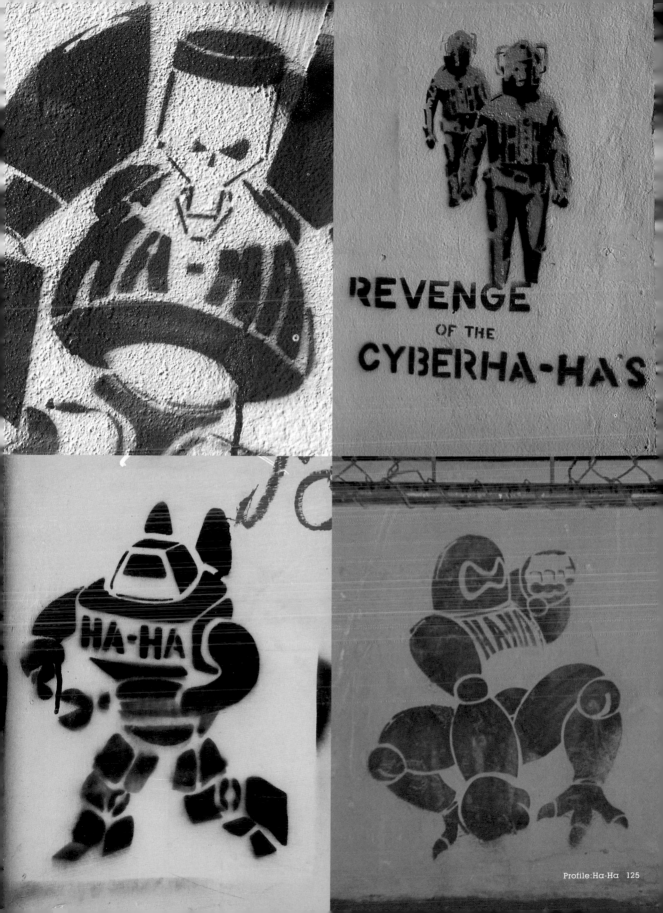

REVENGE
OF THE
CYBERHA-HA'S

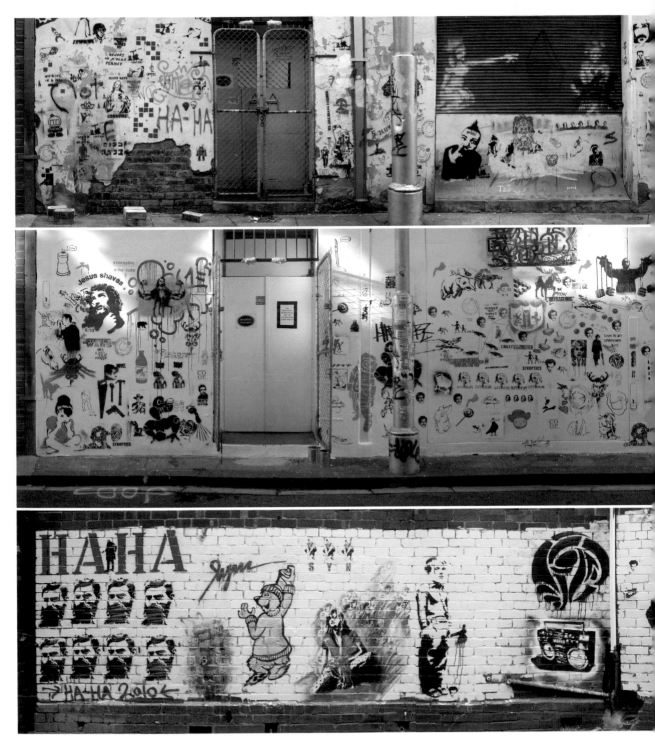

THEME:PUBLIC GALLERIES

Canada Lane, Hosier Lane, Centre Place and other disused alleyways have become "public galleries." They offer the chance to see many artists' work in one place and although illegal to paint, people continually add new pieces to these ever-evolving galleries.

Canada Lane (shown above) has long been a popular lane for stencils. At one stage it was covered in stencils but was about to fall apart and required restoration. Fixed up, in less than 24 hours the first stencil appeared and today the wall is as colorful as ever.

Top to bottom: Canada Lane, Carlton, circa 2002, photo: Prism / Canada Lane, Carlton, circa 2004, photo: Jake Smallman / Unnamed lane off Hanover Street, Fitzroy, photo: Mark Mansour.

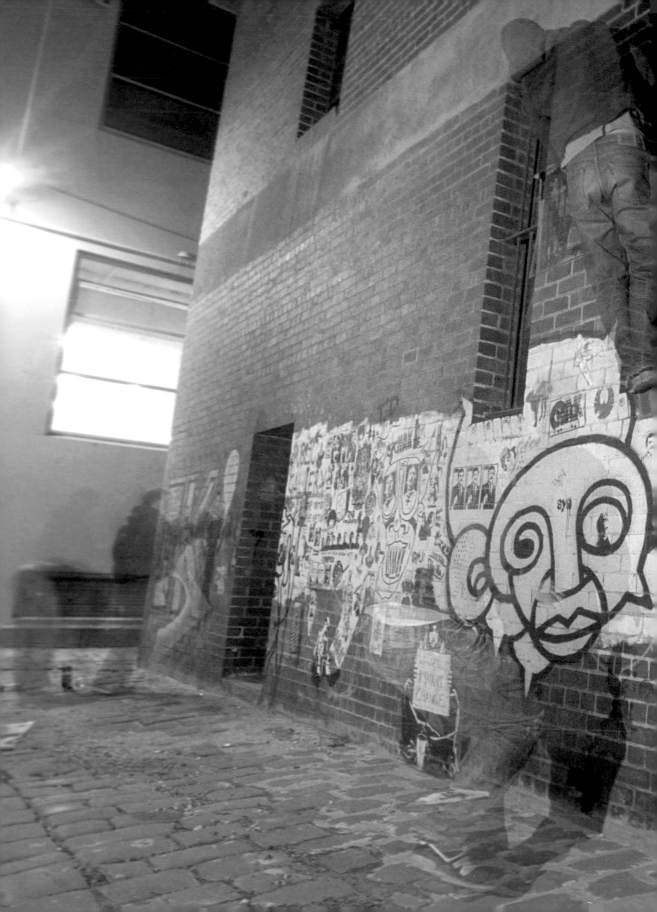

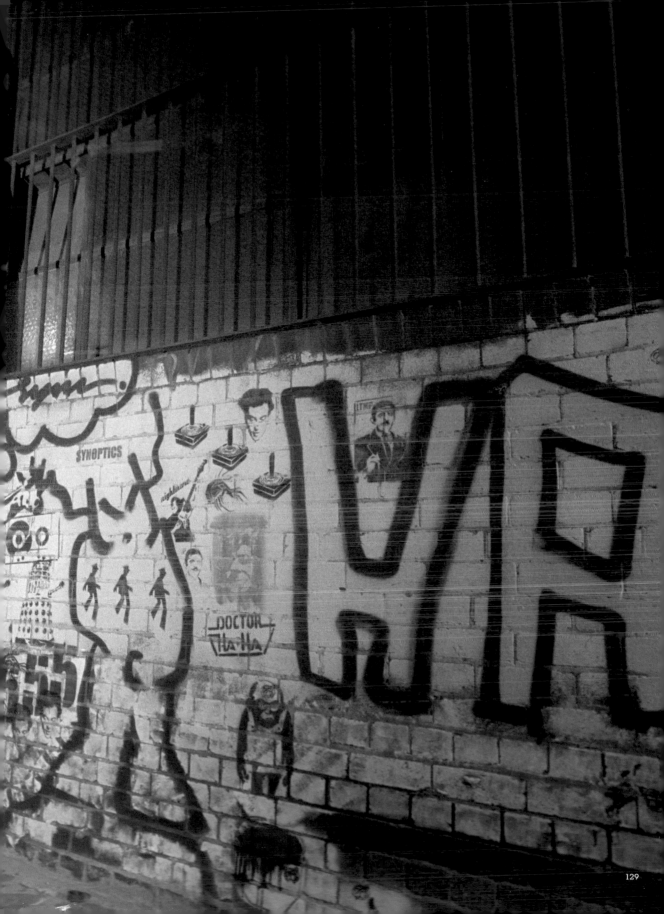

Meggs's style has progressed from politically motivated, one-layer stencils to easily recognizable, clean sprayed, brightly colored, multi-layers. When talking about how he found his own style he says: "I wanted to produce art that had less of an obvious meaning, more abstract and to me, more personal. I find it nice to have a recognizable style. When I first started out, I wasn't following a certain track. In the beginning, you're sort of gathering momentum. Then, once you become confident in using the medium, you start pushing things in the direction you enjoy and develop your own style."

Meggs took his name from a 1960s Australian comic book character, Ginger Meggs, a redheaded kid who likes to get into trouble. Children frequently appear in his work. Meggs hopes it implies "a loss of innocence in our actions as a tongue-in-cheek look at the good and bad sides of human nature."

Today Meggs's work is well recognized in the streets and galleries of Melbourne but it wasn't until 2003 that he got involved in street art on a more serious level. He arrived to the scene just in time for it to explode and describes those days as being full of excitement: "It quickly became apparent that there was quite a big group of people doing this. There was definitely a feeling of unity and of the beginnings of a movement."

One direct result of this movement was "Seesaw," a monthly show that sprung from the forums of Stencil Revolution: "We would meet up in the park to show and swap new work." At these events, stencil artists from all over the city met up. They'd put-up their work, have a few beers, pass a joint around and at the end of the night take home one another's favorite work. Anyone was welcome and everything was free.

Freedom plays into much of what Meggs is all about: "It's a good feeling to express ideas anonymously and feel like you're playing a small part in the visual look of your city, without requiring anyone's permission or approval. It's also a buzz to do something illegal, something outside the parameters of how you're supposed to behave in public."

"I personally love disused buildings, warehouses and the like. Urban exploration in these places is interesting; it shows a history of people's comings and goings. They are great to paint because they provide a one-off naturally decayed canvas that you can take your time painting and if no one's around it's a peaceful place to be. It's like an oasis in the midst of the everyday hustle. I also love that what you've painted there stays there, and the whole environment plays a part in how it looks. Also, the only ones who see it are those prepared to explore as well."

In contrast to these hidden spots, Meggs also likes to hit-up busy locations with high traffic and exposure. For this he prefers to use paste-ups. Since his designs are often multi-layered, he likes to paint them in the safety of his studio, where he can spend more time on his work and ensure a perfect result. When finished he puts them up with plain old wheat paste.

"It reaches a larger audience and it's a buzz to take the extra risk and then think that, if you do it at night, when day hits there are heaps of people walking past it. Hopefully they think, Where did that come from and how did it get there?

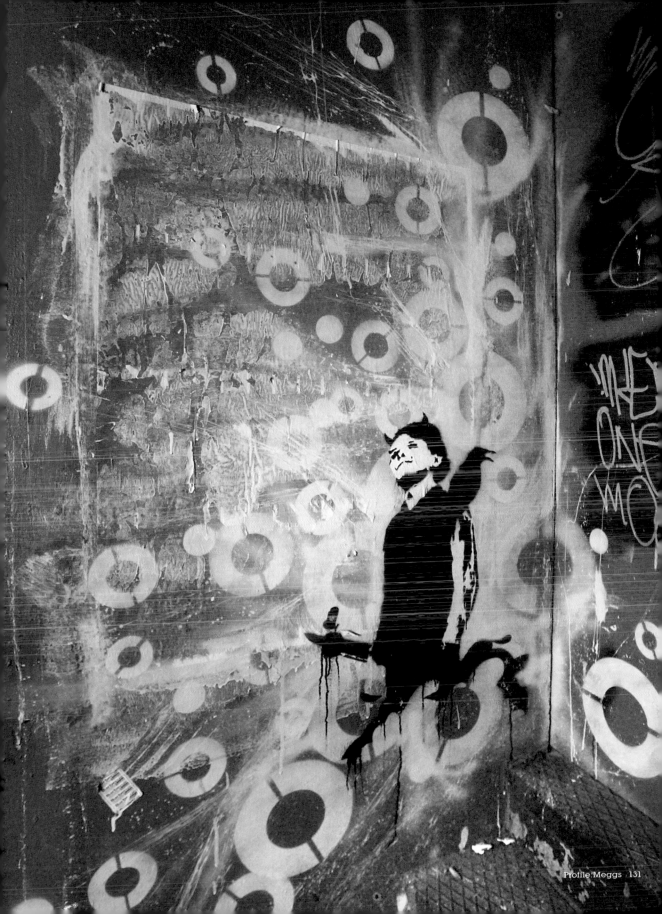

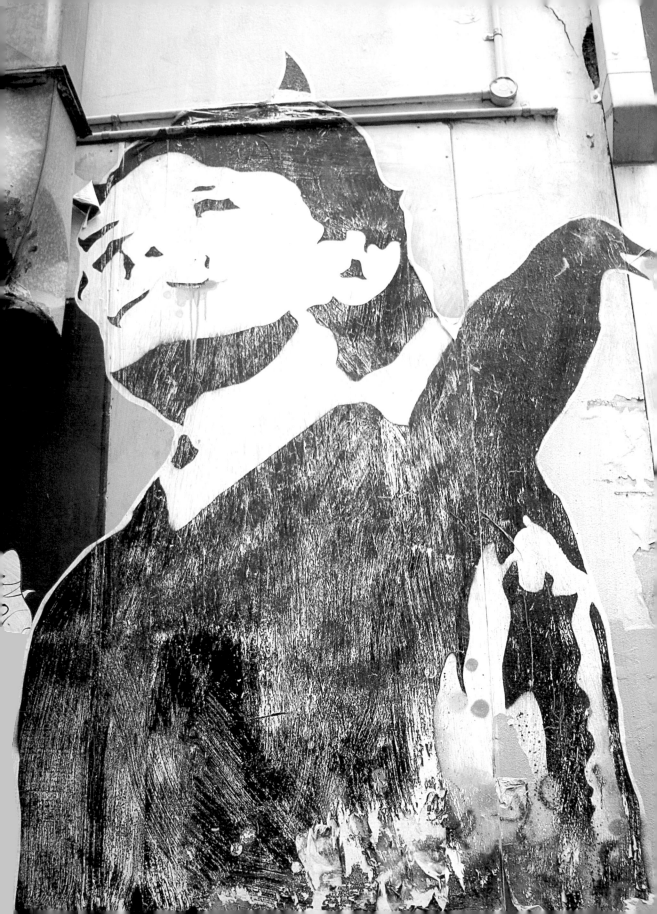

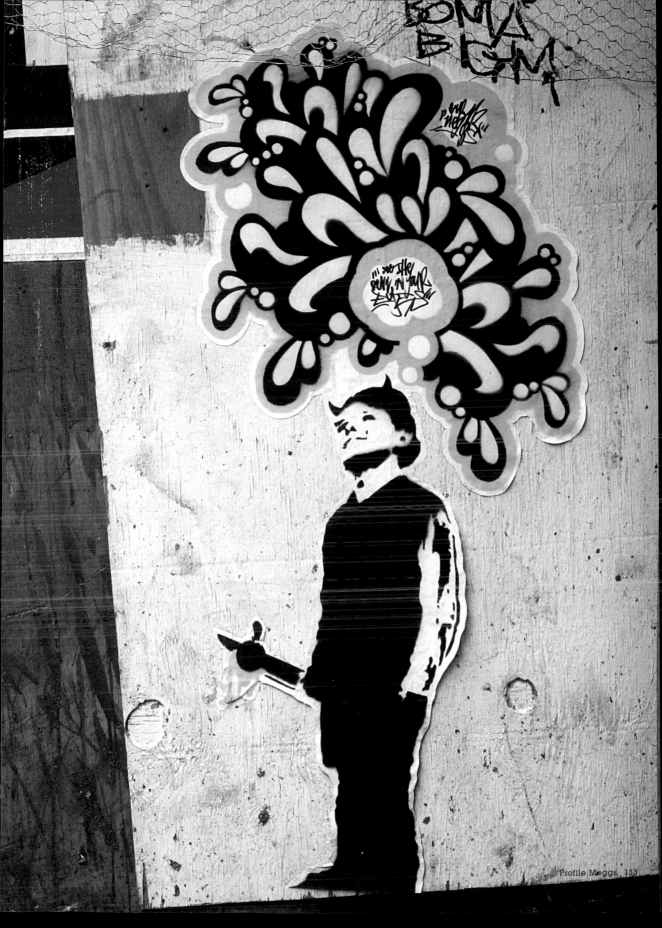

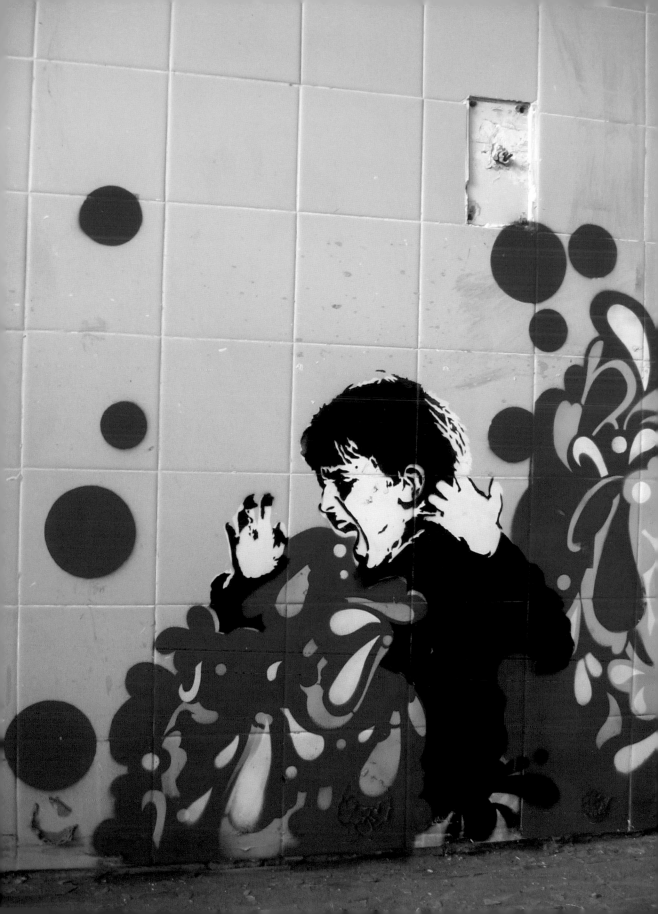

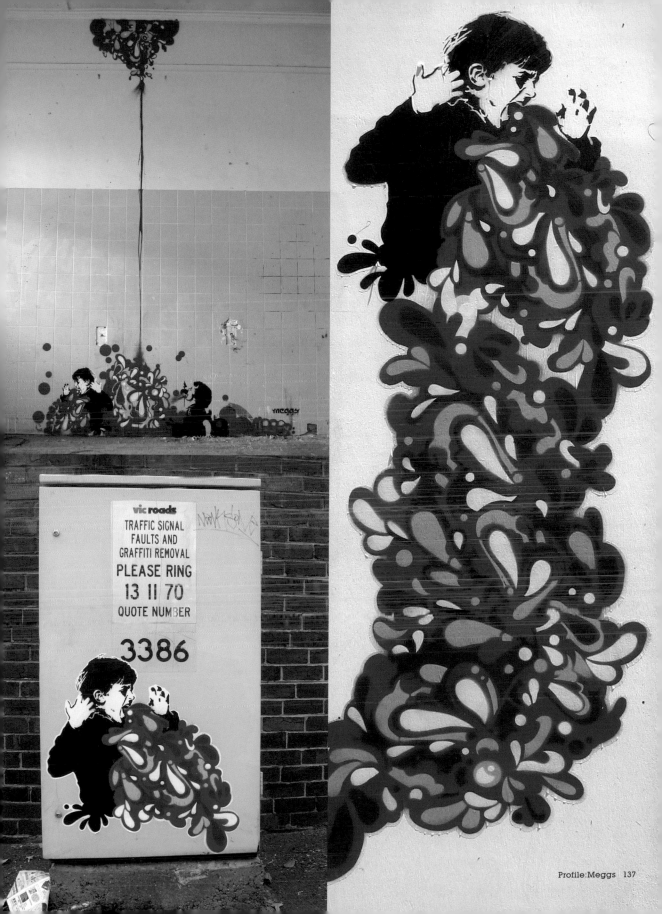

vic roads
TRAFFIC SIGNAL
FAULTS AND
GRAFFITI REMOVAL
PLEASE RING
13 11 70
QUOTE NUMBER

3386

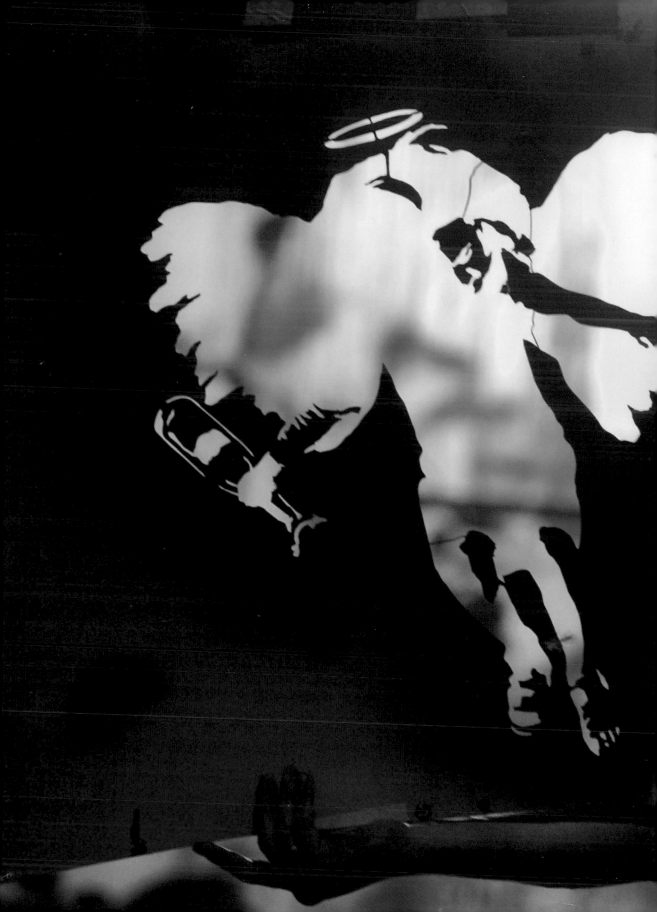

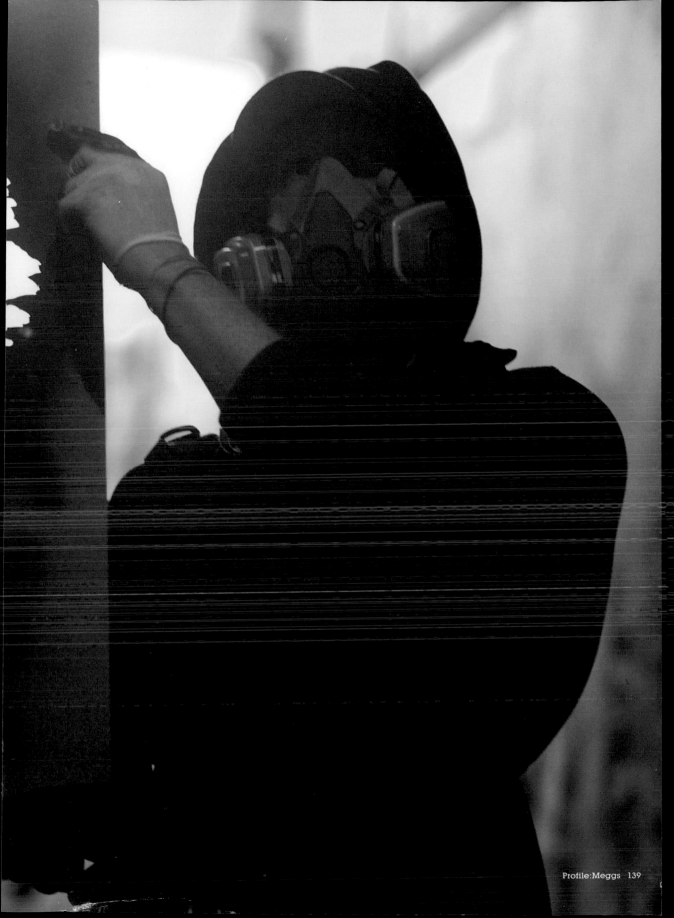

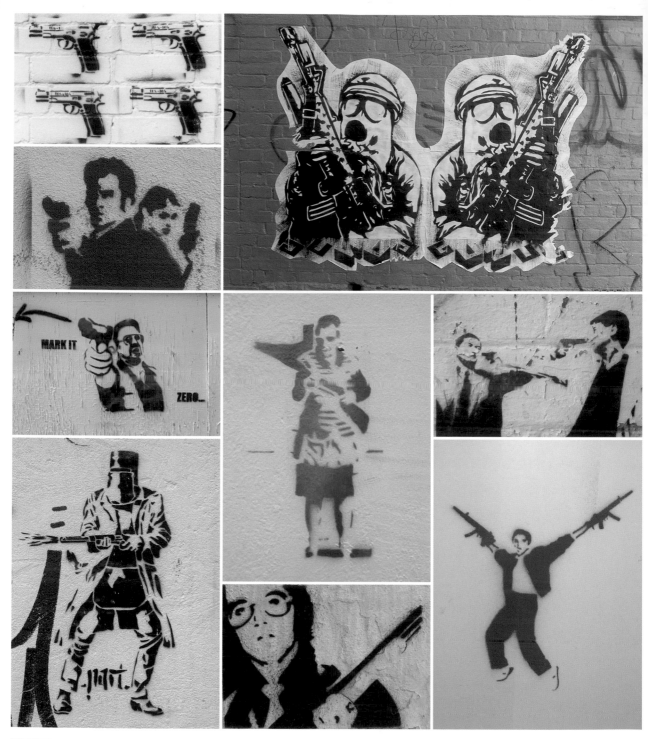

THEME:GUNS

They say that nine out of ten kids prefer crayons to guns. When these kids grow up, some of them trade their crayons for spray cans. Then, for some inexplicable reason, they suddenly start painting guns.

While some of the stencils are clearly anti-firearms, others are meant to provoke and agitate.

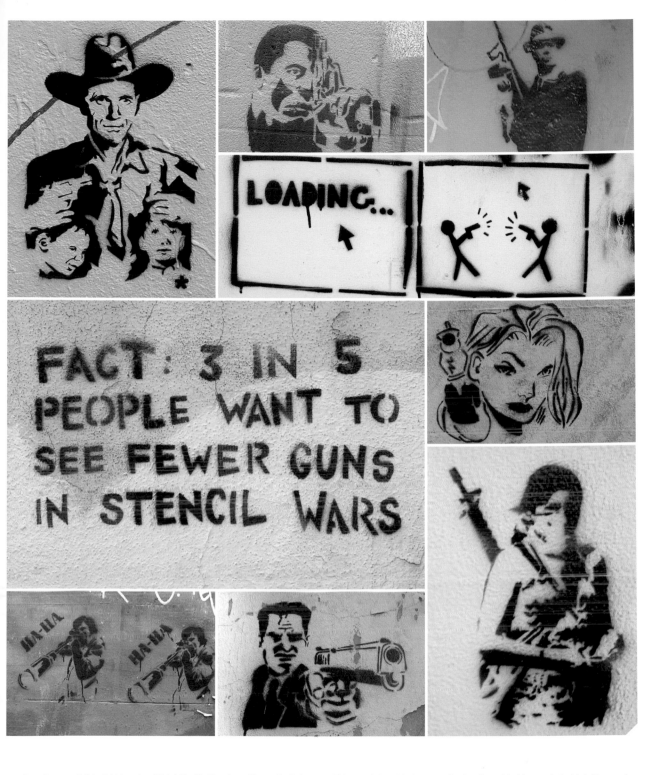

Opposite page, left to right from top: 'Pistols' by Ha-Ha, photo: Shyam Ganju / 'Special Ops' by Guz, photo: Mark Mansour / 'Max Payne', photo: Mark Mansour / 'Big Lebowski', photo: Mark Mansour / 'Young soldier', photo: Mark Mansour / 'John Woo film', photo: Satta / 'Ned Kelly' by Part, photo: Mark Mansour / 'Girl with shotgun', photo: Jake Smallman / 'Elvis' by Ando, photo: Ando.

This page, left to right from top: 'Charlton Heston' by Meggs, photo: Mark Mansour / 'Guy with pistol', photo: Carl Nyman / '20's gangster', photo: Mark Mansour / 'Loading', photo: Peter Casamento / 'Fact', photo: Peter Casamento / 'Girl with pistol', photo: Satta / 'Sniper' by Ha-Ha, photo: Satta / 'Guy pointing pistol', photo: Jake Smallman / 'Guerilla', photo: Carl Nyman.

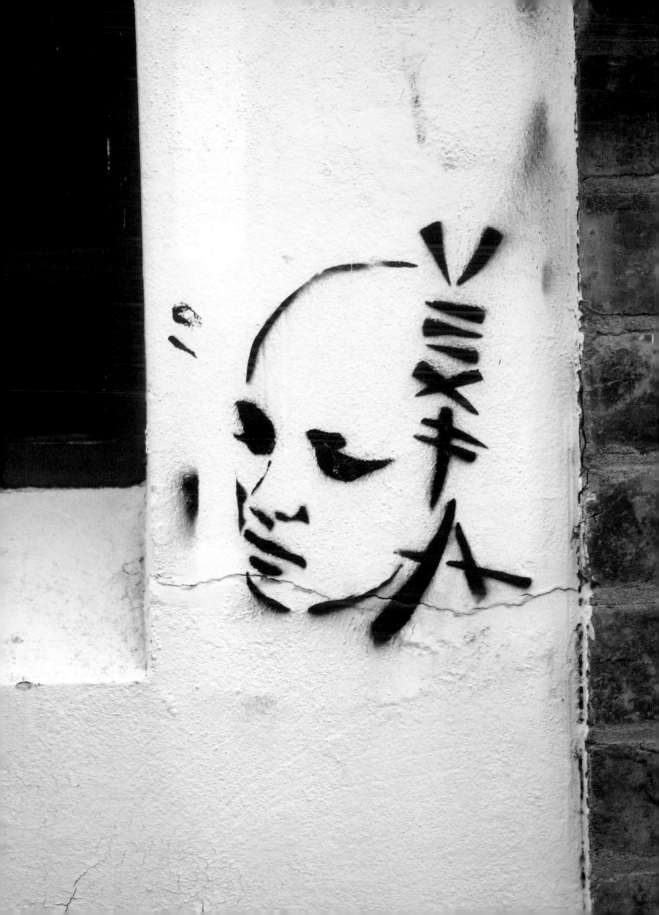

Vexta has been hitting the streets of Melbourne on and off since 2002. With a background in printmaking, the move to stencils was natural. About the shift of mediums she says: "I always felt that as an artist I was looking for my medium. Something I was truly inspired by. I found it a few years ago through what was appearing in Melbourne."

"I moved here from Sydney. It was definitely a conscious thing to move here to create art and find avenues for displaying it. I saw work by Dlux, Ha-Ha, Sync and Optic. Saw what they were doing and thought yeah, I want to add to that."

She gives the impression of someone who cares about her neighborhood and community and although she claims not to be politically motivated some of the ideas she expresses are very socially aware: "I think that stencils, and especially ones that don't include text, break down a lot of social barriers. They can appeal to anybody from any class and also break down language barriers. In that way you can reach a broader audience in the community."

On the street, her first stencil was an image of a two-year-old human skeleton with the text: "This is what a war victim looks like." Vexta explains: "I wanted to remind people of the human consequences of war and try to encourage a bit of debate in the community about what was really going on."

Since then she's made more political stencils but still doesn't subscribe to any particular political viewpoint. "While a certain part of my work is motivated in this way," she muses, "most of it is not. What is most important to me is the transference of emotions. I make all of my pieces with the ultimate aim of connecting with the viewer on an emotional level. I want to find and capture what it is that makes us human, the soul of the individual that is at once personal but at the same time deeply universal. I guess that's why I'm always painting pictures of people I know, my friends."

"In terms of being an artist and making something original, that is quite important to me. I like to use my own work and have a concept from the start which is my own and to create from scratch. I get friends to pose for images that I have in my head. So I may ask a friend to do a particular pose and then I make a stencil out of it. I also use found objects but that's more to, sort of, supplement my own image making."

"I don't like the coldness of our urban environment and I feel that art is extremely important in our society, so I go out there and paint. I put it where people can see it and where it can do the most good, where it can have the most influence on a day-to-day, real level in our world. I try to put forth opinions and ideas not expressed in mainstream media. I like people to bring their own experience and ideas to my art."

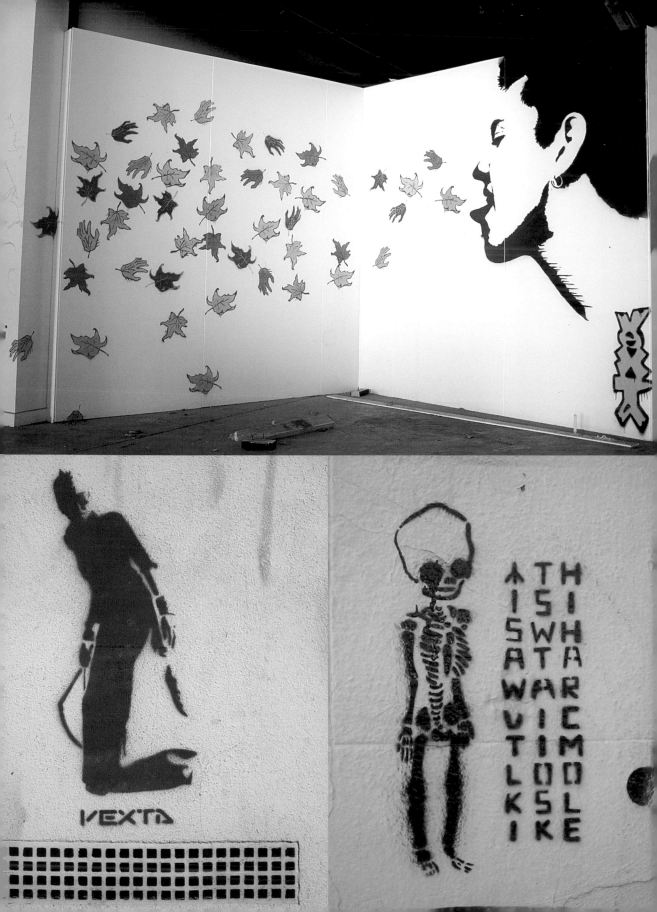

VEXTA

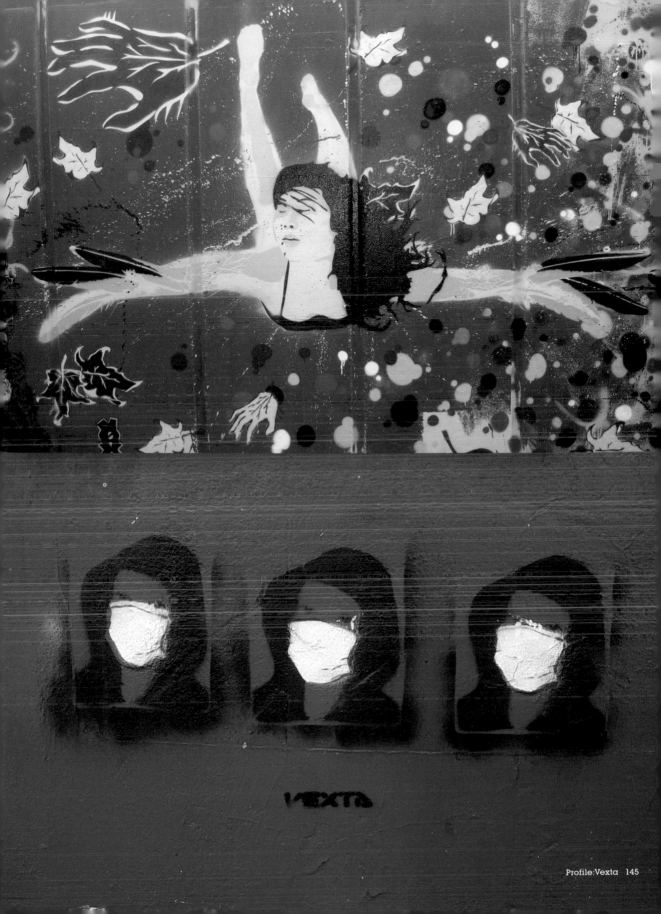

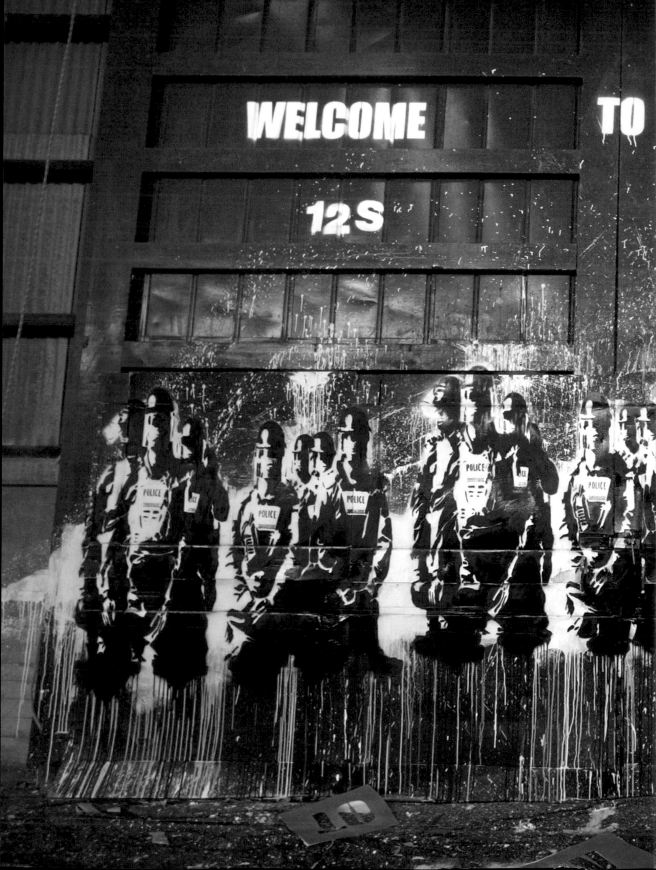

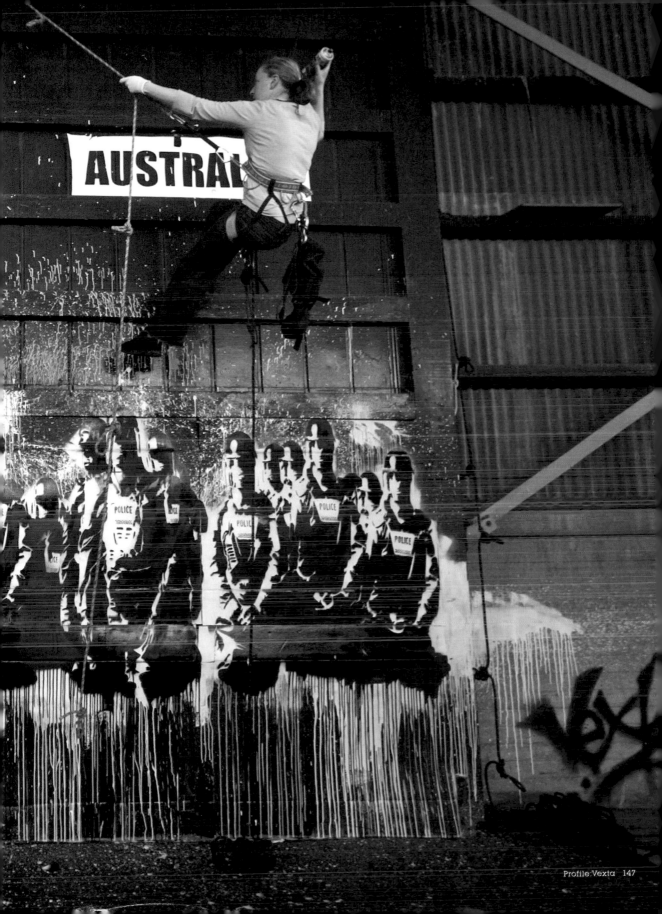

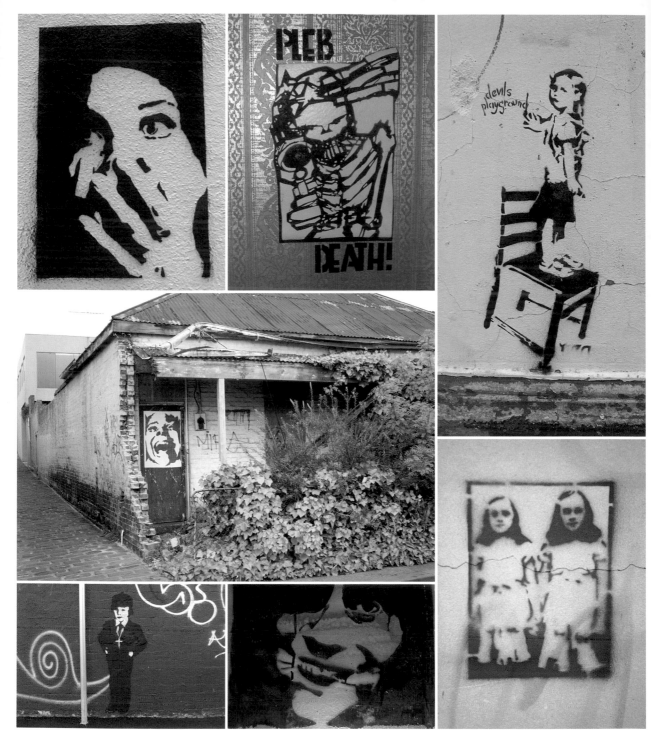

THEME:HORROR

Images of horror, suffering and imminent death haunt the alleyways of Melbourne. No different from our fascination with scary movies, crime scenes and accidents, depictions of horror send chills through our spines and strangely stoke our imaginations.

Some are created purely for shock value or humor while others ridicule our irrational phobias, pointing a finger toward mainstream media's fixation with spreading fear.

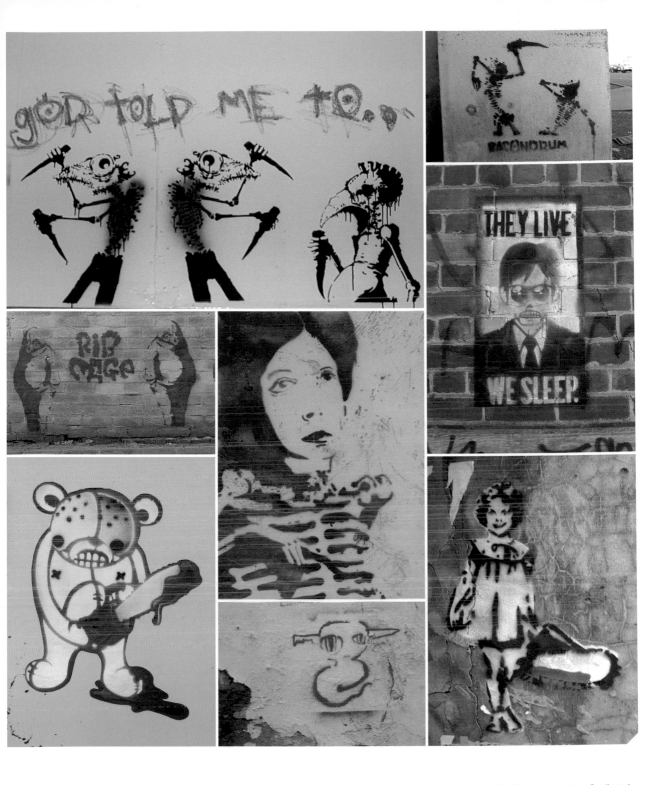

Opposite page, left to right from top: 'Scream' by Sync, photo: Mark Mansour / 'Pleb Death' by Al Stark, photo: Jake Smallman / 'Devils playground' by Meggs, photo: Mark Mansour / 'Haunted house' by Sync, photo: Mark Mansour / 'Damien' by Sync, photo: Mark Mansour / 'Gagged' by Vexta, photo: Jake Smallman / 'Shining twins' by Tusk, photo: Tusk.

This page, left to right from top: 'God told me to' by Ribcage, photo: Jake Smallman / 'Bacondrum' by Ribcage, Photo: Satta / 'Bird creatures' by Ribcage, photo: Jake Smallman / 'Skeleton Girl' by Ribcage, photo: Mark Mansour / 'Psycho teddy' by Spunky, photo: Mark Mansour / 'Creature' by Vexta, photo: Carl Nyman / 'Shirley Temple with chainsaw' by Rone, photo: Carl Nyman.

Rone draws inspiration from skateboarding, fashion and video games. Especially in his early stencils the skateboarding influence is prominent, both in motifs and placement.

He started out in 2002 decorating skate decks and skate parks. Soon his stencils spread to the streets and eventually made their way into galleries. Out on the street, Rone often chooses high traffic areas to paint. He says it's the adrenaline rush from the risks involved that drives him: "It gives you a great buzz when you pull it off."

When the police raided the Canterbury "Empty Show," Rone was one of three artists busted. He was caught a few hours after the raid while trying to recover stencils and paint cans that were ditched when the police first arrived.

The police expected someone would return for the materials, so they waited. "They made me tear up all the stencils and kept asking if I was part of some sort of underground network," he laughingly recalls. Luckily, with the exception of the lost paint and stencils, nothing came of it, not even the fine promised to him by the police.

"You know, it's all part of the fun. It's about being chased and stuff. It's kind of like skateboarding. It's all part of it. You skate in school and you get kicked out. You stencil a wall and you get fucking busted."

Apart from skating-based imagery, Rone has become well-known for a series of large-scale women's faces. With a fixed stare into the distance, they are both beautiful and at the same time sad, often featuring crying or bleeding eyes. Rone's interest in how fashion photography tries to capture an exact look inspired him to create these pieces: "It's all about the expression on the girls' faces; they are sad or maybe angry; it's somewhere between; vengeance springs to mind. They are beautiful and supposedly the weaker sex, but the look says these girls aren't to be fucked with."

Often approaching nine feet in height, their size has meant that stenciling onto paper and using wheat paste to stick them up has proven the easiest way to get these up in high-traffic areas: "I also like the fact that pasting a stencil up means you aren't dependent on the color of the wall; you get a perfectly white background every time." Rone also likes the way paste-ups tend to age: "The way they deteriorate can really add to the look."

There seldom is a message behind Rone's stencils and he says that he doesn't like to think too much about what he's doing and why: "If you think about it too much, it becomes a problem. I paint because I love it and it brings the streets to life."

About stencils suddenly being trendy and rapidly becoming mainstream, Rone doesn't mind: "Some people are like, as soon as it becomes big it's suddenly not cool anymore. A lot of people are like that with bands. But if the band was sick six months ago when you were the only one who had heard about them, they're still going be sick today even though every fucking teenybopper knows about them. It just makes them less underground."

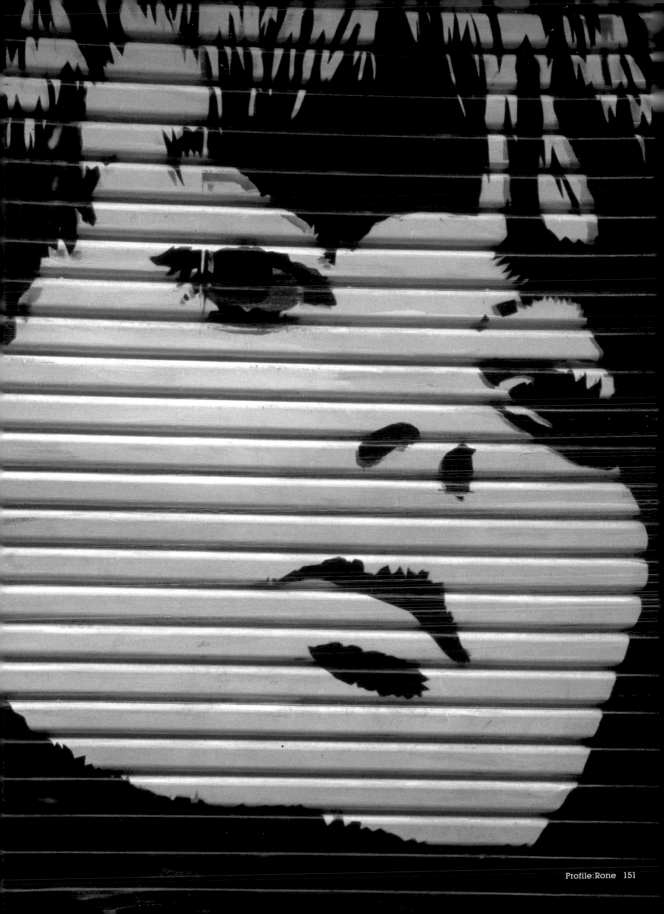

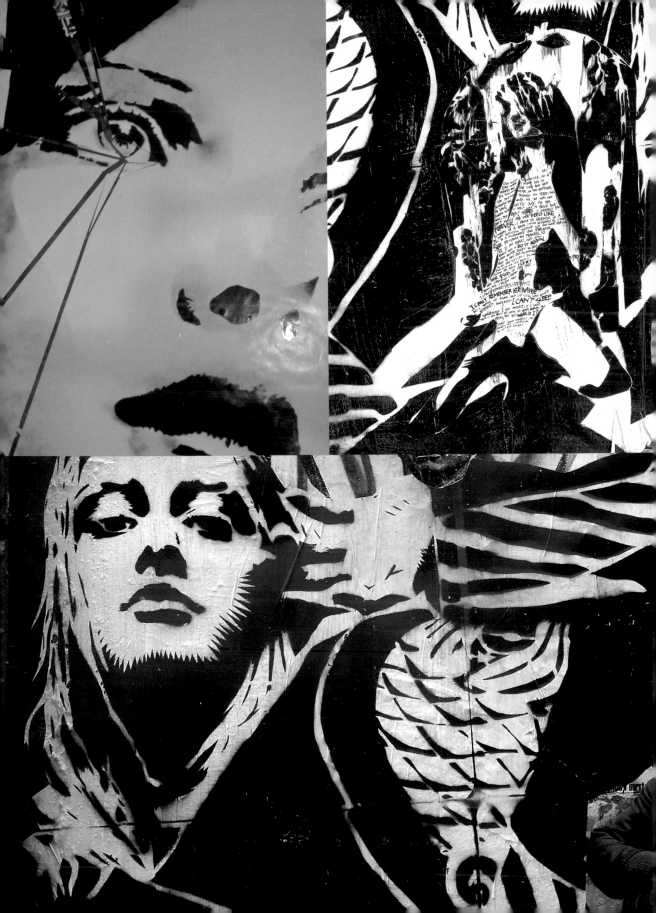

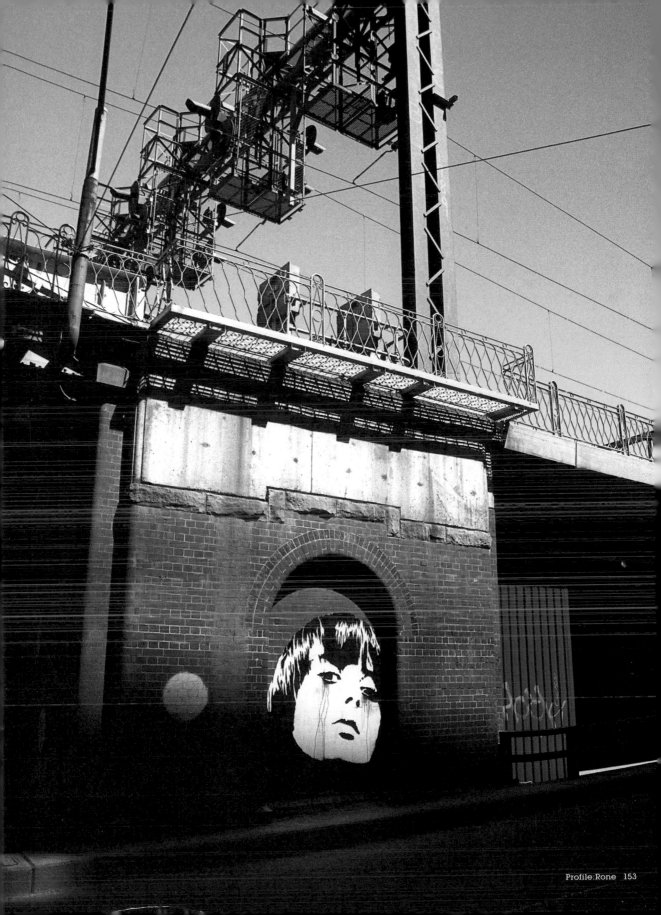

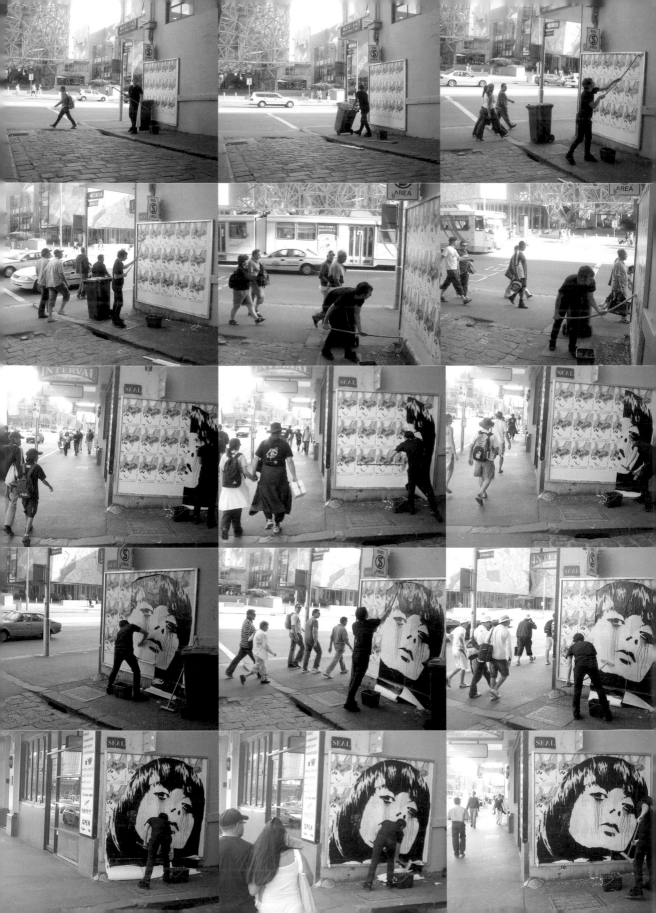

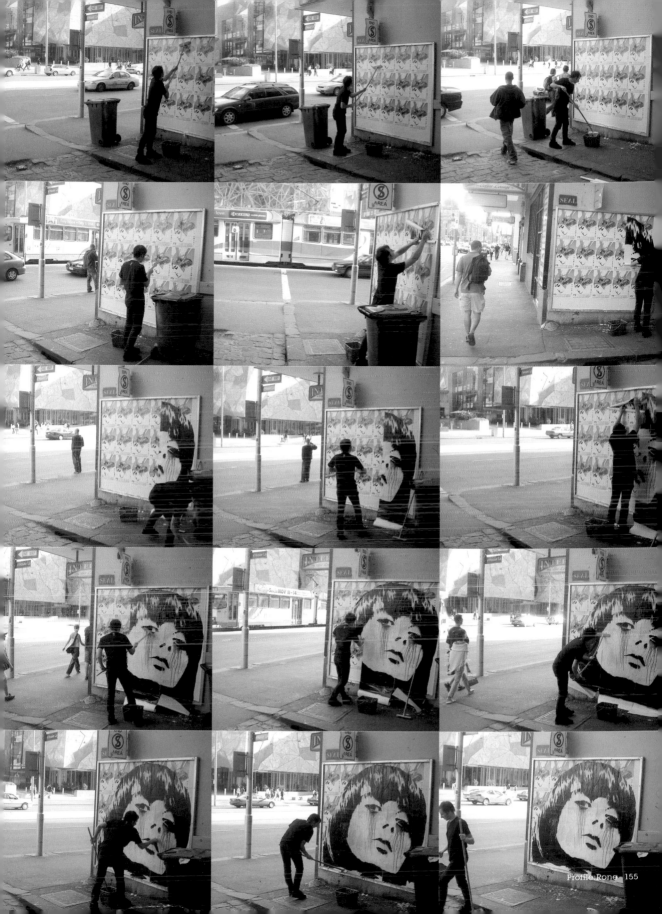

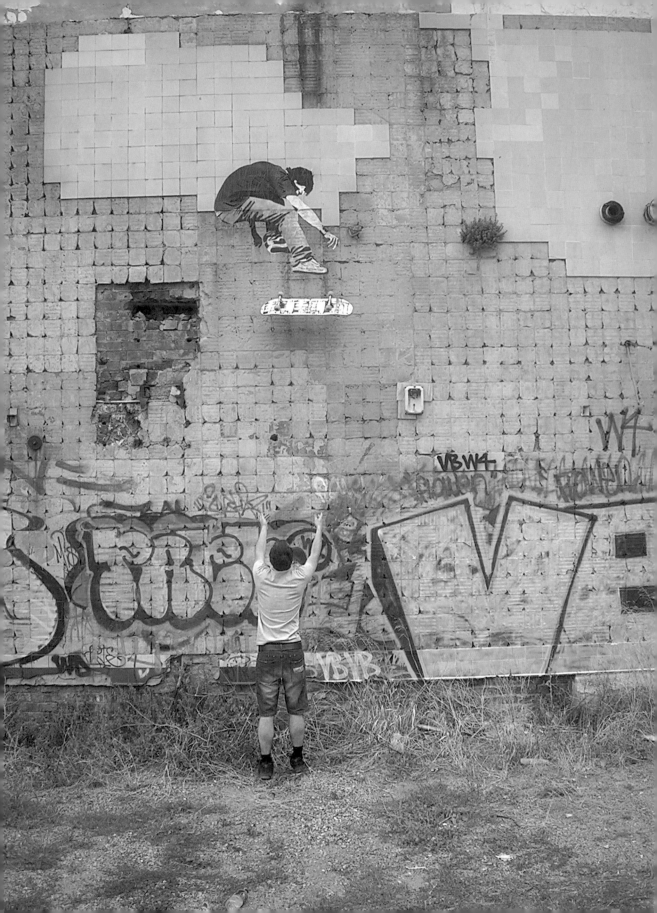

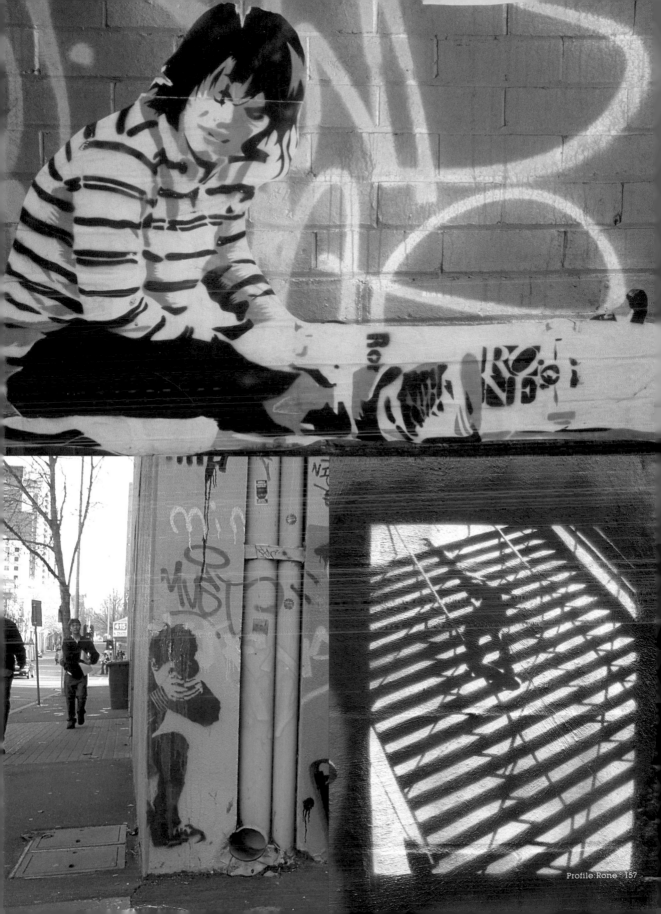

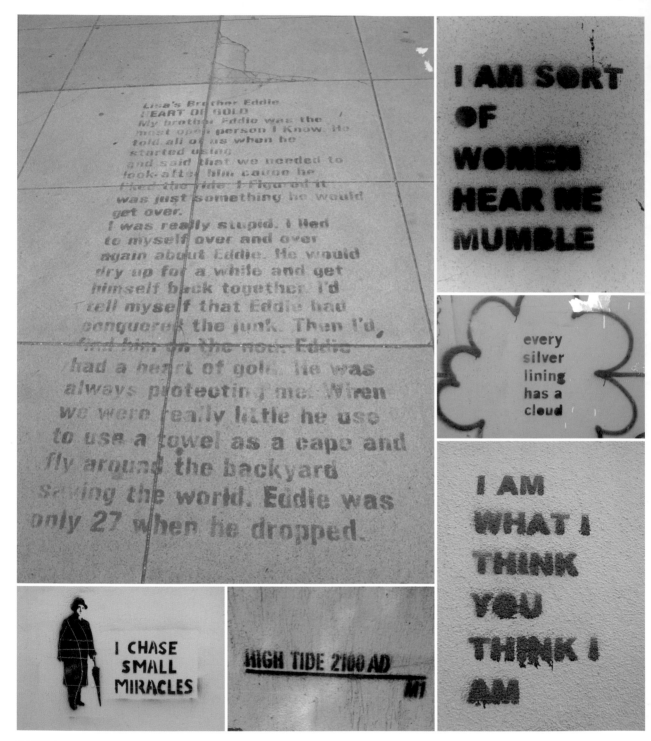

THEME:TEXT

Stencils have long been used for spreading messages of propaganda in times of unrest. Taking only seconds to apply, a stencil is the quickest way to put a clear message on a wall. Cutting out letter after letter takes some time but once finished the words can be spread fast, with the same result on every spray. Territorial, silly, serious or antagonistic, today propaganda takes the form of humor, philosophy, poetry, calls to action and personal thoughts made public.

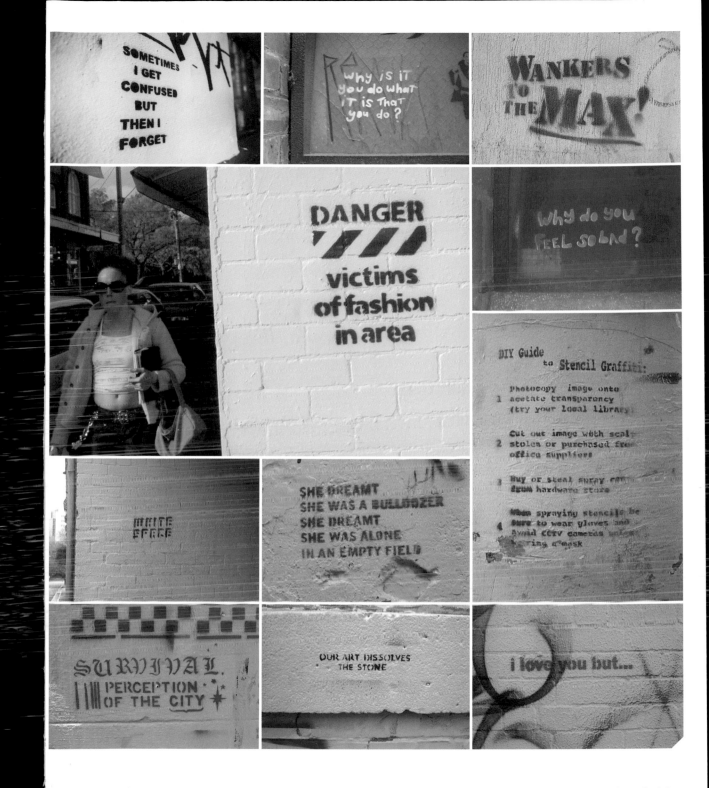

Opposite page, left to right from top: 'Heart of gold', photo: Jake Smallman / 'Sort of woman', photo: Shyam Ganju / 'Every silver lining has a cloud', photo: Jake Smallman / 'I chase small miracles', photo: Jake Smallman / 'High tide 2100AD', photo: Jake Smallman / 'I am what I think you think I am', photo: Mark Mansour.

This page, left to right from top: 'Sometimes I get confused', photo: Shyam Ganju / 'Why is it...' by Doyle, photo: Jake Smallman / 'Wankers to the max', photo: Mark Mansour / 'Victims of fashion' by Banksy, photo: Paul West / 'Why do you feel so bad?' by Doyle, photo: Jake Smallman / 'White space', photo: Mark Mansour / 'She dreamt', photo: Satta / 'DIY Guide to stencil graffiti', photo: Mark Mansour / 'Survival' by Civilian, photo: Carl Nyman / 'Out art dissolves the stone', photo: Jake Smallman / 'I love you but...', photo Carl Nyman.